A Potter's Mexico

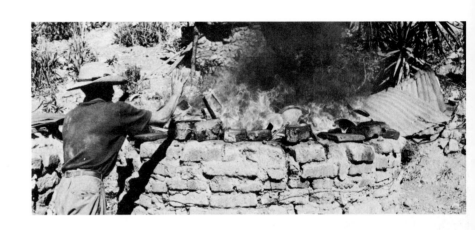

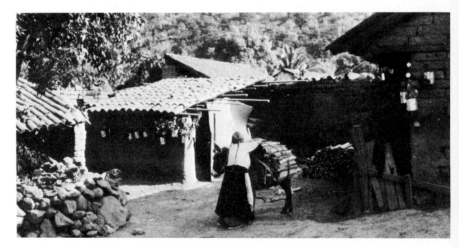

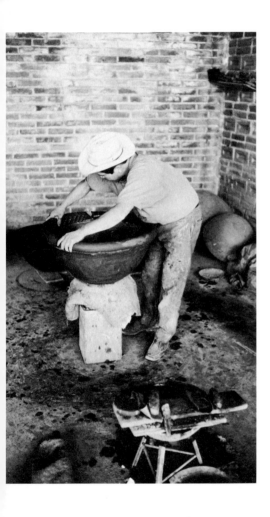

A Potter's Mexico

Irwin &
Emily Whitaker

UNIVERSITY OF NEW MEXICO PRESS

Albuquerque

Library of Congress Cataloging in Publication Data

Whitaker, Irwin.
　A potter's Mexico.

　Bibliography: p. 130
　Includes index.
　1. Pottery, Mexican.　2. Pottery—20th century
—Mexico.　3. Potters—Mexico—Biography.
I.　Whitaker, Emily.　II.　Title.
NK4031.W47　738′.0972　77-29047
ISBN 0-8263-0472-9

Library of Congress Catalog Card No. 77-29047
International Standard Book Number 0-8263-0472-9
First Edition

For
Fulano de Tal,
Mexican Potter

Un Brindis
(A Toast)

Salud

John Hunter, Pacha Murillo, Señor Carlos Espejel, John Cantlon, the Staff of the Hotel Polanco, Rita Knoll, Señor Enrique de la Lanza, Joe Spielberg, Homer Higbee, and Erling Brauner.

Pesetas

The Ford Foundation; the MSU Foundation; and Michigan State University's Office of Research & Development, Center for International Programs, Latin American Studies Center, College of Arts & Letters, the Humanities Research Center, and Department of Art.

Amor

Tina Villanueva, Noah Alonso, Salvador Guerrero, Dick Sullivan, Larry Perrine, Pipis Guerrero, Marc Hansen, Betty Taylor, Enrique Ruiz, Bev Suits, Russ Phelps, Kitty Perrine, Alan Suits, and Guadalupe Fonseca de Garzafox.

y Tiempo para gozarlas

Dave Bailey, Flora Phelps, Rick Petterson, Paul Love, John Taylor, and Frank Wardlaw—who headed us in the right direction.

Contents

Map ix

Introduction xi

1. Firing, Fuels, and Kilns 1

2. The Clay: Its Forming and Finishing 25

3. The Everyday Pottery of Mexico: *La Loza Corriente* 52

4. The Decorative Pottery of Mexico: Ten Major Pottery Centers 72

5. The Artists 101

Glossary of Mexican Pottery Terms 125

Bibliography 130

Index 134

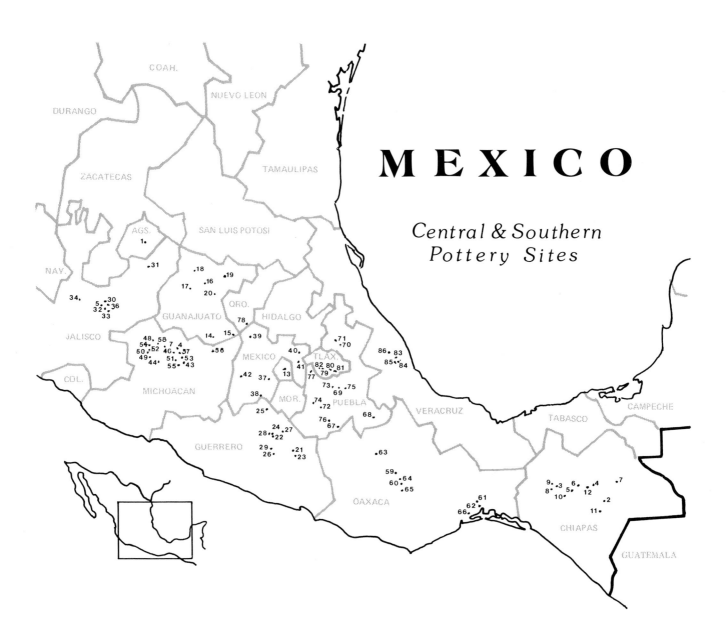

MEXICO

Central & Southern
Pottery Sites

AGUASCALIENTES

1. Aguascalientes (state capital)

CHIAPAS

2. Amatenango del Valle
3. Berriozábal
4. Chamula
5. Chiapa de Corso
6. Ixtapa
7. Ococingo
8. Ocozocoautla
9. Ocuilapa
10. Suchiapa
11. Venustiano Carranza
12. Zincancantán

DISTRITO FEDERAL

13. México (Mexico City)

GUANAJUATO

14. Acámbaro
15. Coroneo
16. Dolores Hidalgo
17. Guanajuato (state capital)
18. San Felipe Torres Mochas
19. San Luis de la Paz
20. San Miguel de Allende

GUERRERO

21. Acatlán
22. Ameyaltepec
23. Atzacualoya
24. Huapan
25. Taxco
26. Tixtla
27. Tulimán
28. Xalitla

29. Zumpango del Río

JALISCO

30. El Rosario
31. Encarnación de Díaz
32. Santa Cruz de las Huertas
33. Tatepozco
34. Tequila
35. Tlaquepaque
36. Tonalá

MÉXICO

37. Metepec
38. Tecomatepec
39. Temascalcingo
40. Teotihuacan
41. Texcoco
42. Valle de Bravo

MICHOACÁN

43. Capula
44. Cocucho
45. Coeneo
46. Comanja
47. Huánzito
48. Ichán
49. Ocumicho
50. Patamban
51. San Jerónimo
52. San José de Gracia
53. Santa Fe de la Laguna
54. Santo Tómas
55. Tzintzuntzan
56. Zinapécuaro
57. Zipiajo
58. Zopoco

OAXACA

59. Atzompa
60. Coyotepec
61. Ixtáltepec
62. Juchitán
63. Nochixtlán
64. Oaxaca (state capital)
65. Ocotlán
66. Tehuantepec

PUEBLA

67. Acatlán
68. Altepexi
69. Amozoc
70. Aquixtla
71. Chignahuapan
72. Izúcar de Matamoros
73. Puebla (state capital)
74. San Marcos Acteopan
75. Ocotitlán
76. Tehuitzingo
77. Texmelucan

QUERÉTARO

78. San Ildefonso

TLAXCALA

79. La Trinidad Tenexyecac
80. San Juan Totolac
81. San Sebastián Atlahapa
82. Santiago Xochimilco

VERACRUZ

83. Blanca Espuma
84. Cerro Gordo
85. Rancho Nuevo
86. San Miguel Aguazuela

Introduction

Perhaps more than any other area of the world, Mexico, throughout evolution and revolution, has depended upon products made of clay. Clay has invested with dignity every facet of Mexican life from cradle to grave. That dependence upon clay continues today, physically, spiritually, and aesthetically.

This book is an attempt to record, through photographs and words, before it is too late, a unique art form as it exists now and to plead for its survival. The diversity of techniques used by contemporary Mexican potters ranges from the crudely primitive to the highly sophisticated. For the professional potter, as well as for the casual student of crafts or folk arts, a study of Mexican pottery offers a living compendium of ceramic history. In Mexico the tenth and the twentieth century lie side by side in the same connubial bed.

With changing social needs and machine-made products, the bulk of Mexican pottery is fast becoming an anachronism. The human hand, though trained to perform amazing feats of dexterity, cannot compete in efficiency with machines. As Mexico becomes increasingly industrialized, many hand-crafted pottery objects will disappear. Others will undergo radical change. Many are already gone, more will go, and changes will soon transform what is left.

This book presents the combined observations of two quite different people (one with extensive knowledge of Mexican history and culture, and the

other an experienced artist-potter-teacher) who watched Mexican potters at their craft and came to respect and admire both them and their work.

The study began as a rather lighthearted venture to give focus to what otherwise was to be a vacation and delayed honeymoon. We left Michigan in early April 1971 to spend the spring and summer in Mexico, with the vague idea of gathering material for a short article or two on Mexican pottery.

As the summer progressed, our attitudes toward the entire undertaking began to change. First, the tunnel vision of Irwin, the U.S. teacher-potter trained in the international stoneware tradition, was being swept aside by the daily exposure to Mexican low-temperature wares of dignity and, often, great beauty. Second, Emily, the social historian, already frustrated by the dearth of published information, was becoming more and more incensed that so little attention was paid to what we both saw as an important part of Mexican history and culture. Finally, we concluded that since a great deal of what today's scholars know about pre-Hispanic Mexico they have learned from its ceramic artifacts, it was imperative to document, as best we could, the continuation of Mexico's ceramic story.

By mid 1971 the lighthearted, if not frivolous, task we had set ourselves had expanded into an all-consuming project. Our article or two had ballooned, in our minds at least, into a book.

Early in our first trip we developed a working technique. Emily, who has lived in Mexico on and off for many years and whose Spanish is fluent, always made the initial approach, explaining to the potters who we were and what we were trying to do. Next, Irwin brought out photographs of his own works and sometimes demonstrated unfamiliar techniques, using clay or pen and ink. Then, while Emily continued chatting with the potters, now busy again at their work, Irwin faded from the group and started to photograph.

All the photographs in this volume are his, many of them shot in situ with available light. Always we requested permission to photograph; if it was refused, we let the matter drop. We did not carry flash or strobe, and it never crossed our minds to invade our friends' privacy with a tape recorder. Once back in our hotel room, after the evening meal, we made our notes, recording what each of us remembered of the day's events.

We traveled by plane, in our own station wagon, by pickup truck, on

foot, in taxis, and once, unforgettably, by oxcart. Almost without exception, wherever we went, we were greeted warmly and treated graciously by the people with whom we talked. They shared with us whatever they had: pollo, arroz, and country tortillas; for our part we responded with Pepsi, U.S. cigarettes, and an occasional Band-Aid.

Many of our travels were "treasure hunts," tracing down leads from obscure publications, from conversations with merchants in village markets, and occasionally from sheer rumor. Many of our leads proved misleading. Sometimes we were told: "Sure, pottery used to be made here but the potter died," or: "She's moved away," or: "María used to make pottery, but she doesn't any more." Once in a while we found a potter or two who made something now and then for local consumption, but such work is rarely seen more than a few kilometers away. At times we were told: "No, there's no pottery made around here," only to discover that while the village contained but a few hundred souls, its potters were unknown to other townspeople. Very occasionally we found the "No" to be correct; the pottery we sought came in fact from another village of the same name on the other side of the state, or the pottery attributed to one village was in fact made in another nearby village which was accessible only by foot or by burro.

On our first trip we were constantly excited by the stylistic and technical differences we saw. As we became more knowledgable, our interest accelerated, for we were discovering subtle distinctions between villages producing similar work. Eventually we came not only to recognize the differences between areas but also to identify the works of certain individuals. Then we began to catalog as many pottery-making places as our time and energy would permit, always hoping that we would turn up something new and startlingly different. While much of what we saw during this period was similar to things we had already seen, our enthusiasm continued unabated, until our time ran out.

On our second trip our main concern was to visit villages we had learned about but which, because of bad weather, illness, or lack of time we had been unable to reach on the first trip. We were anxious, also, to renew our friendships with many potters, to confirm our first impressions, and to gather additional information.

Our third trip was a balm to relieve the itch of doubts brought on by the reading and research we had done in the United States following the previous trip. Unlike our earlier journeys, this one was tightly organized. Traveling mainly by air, we returned to southern Mexico, talked to potter friends, and in several villages verified our original observations.

On the map we have listed the eighty-six places where we know pottery is made. These include isolated villages where less than a handful of women make pottery on a spasmodic basis as well as larger towns where everyone— man, woman, and child—produces pottery pretty much fulltime. There are other areas where we are certain pottery is produced but we have no personal proof, still others where we suspect there is pottery, and, undoubtedly, others which have escaped our attention entirely.

We have chosen to divide contemporary Mexican pottery into two general categories. The *corriente*, or common everyday utilitarian pottery, and the "decorative" or "ornamental," which came originally from Indian wares designed for ceremonial purposes. In pre-Hispanic Mexico it was probably the women who made the common ware, and the privilege of creating the ceremonial was the prerogative of the men. The same division of labor holds true today in some regions.

Mexican pottery cannot be fully understood or appreciated without some consideration of the *corriente*, which was designed to serve a definite function and a particular kind of life-style. For many Mexicans that life-style has changed little over the centuries, and many types of *corriente* continue to be made in the same manner and in the same shapes and for the same purposes. In the chapter on *corriente* we have sometimes used the Spanish or Indian terms, not because they cannot be translated, but because such English equivalents as stewpots, cups, or beanpots may call to mind specific objects unlike those to which we refer.

A companion chapter is devoted to what in our eyes are Mexico's major ornamental pottery centers. (Most of these also produce *corriente*.) Almost all of them lie within the historico-cultural heart of Mexico, a wide west-east belt running from the states of Nayarit and Jalisco to Veracruz. In the north this section balloons out to encompass parts of Aguascalientes and San Luis Potosí and in the south, portions of Michoacán and Puebla. Beyond this cen-

tral band only the states of Guerrero, Oaxaca, and Chiapas are important for their pottery.

We have chosen not to include in this chapter other areas in which ornamental pottery is made since their output is either minute in quantity or of little significance stylistically. In Tehuantepec, for example, in the San Blas section, and in Juchitán, potters use the slow wheel, which may be of technical interest, but, with the exception of the water jars (locally known as *tinajeras*), the pottery is quite ordinary or tastelessly decorated. Again, in the rugged coastal hills of the State of Veracruz, a few interesting decorated water-carrying jars are made by pre-Hispanic hand-building techniques but are fired in the Spanish-style open-top kilns. Authentic pre-Hispanic building and firing methods of pottery which might be considered ornamental may also be observed in a number of villages in the State of Chiapas near Guatemala. The most easily accessible of these is Amatenango del Valle just off the Pan American Highway. Though the Amatenango jars have changed little in form or decoration over the years, some are now purchased by "more sophisticated" potters in nearby Chiapa de Corzo, who glaze them for sale in the capital city of Tuxtla Gutiérrez.

One vicinity that we found intriguing—not because of its pottery, which is unremarkable, but because of its strange partially domed kilns—was Aquixtla and its satellite villages in the State of Puebla. (Somewhat similar kilns are used in La Trinidad Tenexyecac in Tlaxcala, famous for its mammoth stewpots.) We have also seen pottery identified by persons we trust as coming from specific villages in the remote mountains of west-coast Oaxaca. Our first impression upon seeing it was that the decoration was distinctly African in flavor. Since then we have learned that somewhere in this region there is a small African enclave but, lacking personal observation, we can only speculate about the possible African influence.

We have also omitted any discussion of the large modern pottery and tile factories of Mexico City and Monterrey, as well as many smaller shops such as those in the cities of Oaxaca and Guanajuato, the Taxco area, and Tlaquepaque in the State of Jalisco, whose production methods, and sometimes designs, are virtually indistinguishable from those of the United States and other industrialized countries.

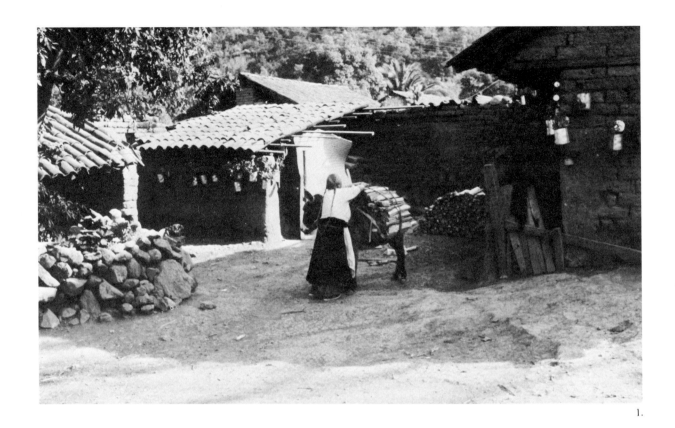

1.

2.

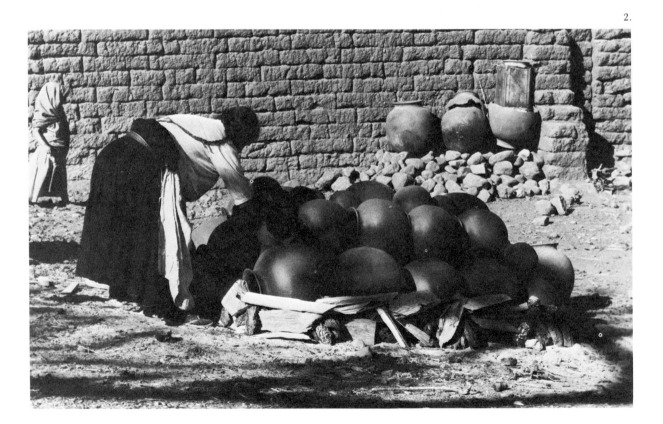

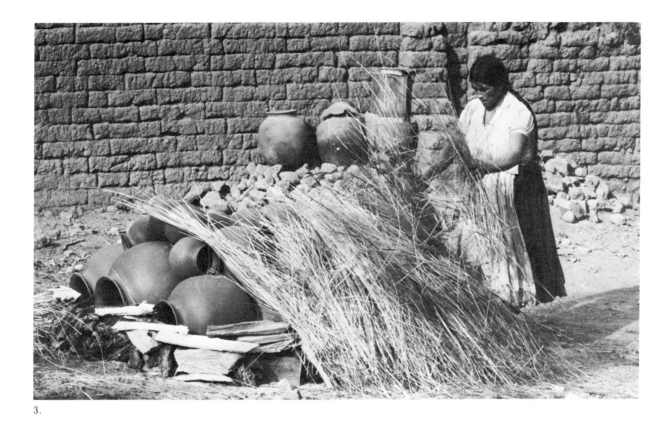

3.

Figure 1. Traditions die hard. Sometimes when a man says he is a potter there is spontaneous laughter of disbelief. Here every facet of pottery making from digging the clay, to gathering the fuel, to the firing process itself, is women's work. Zipiajo, Michoacán, 1973.

Figure 2. In open firing the proper fuel is critical. Even-burning wood and high-caloric reeds gathered in the nearby mountains are the preference in parts of Tarascan Michoacán. Zipiajo, Michoacán, 1973.

Figure 3. If reeds are in short supply and none can be borrowed from a neighbor, the pile may be topped off with common straw, giving the appearance of a haystack. Zipiajo, Michoacán, 1973.

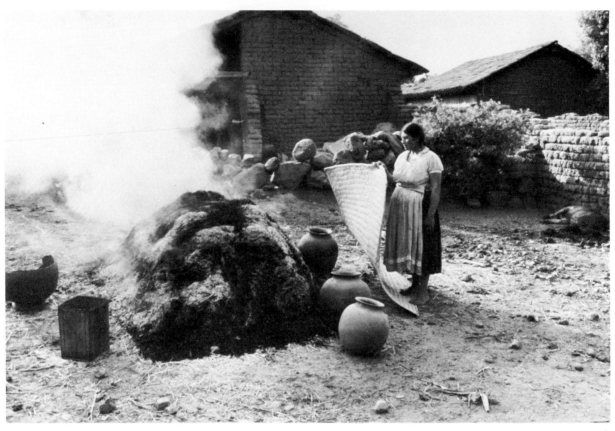

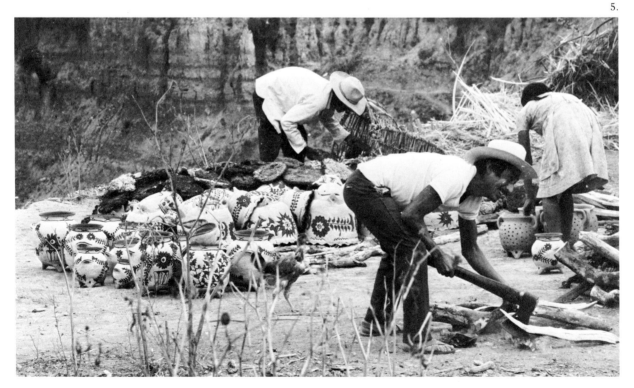

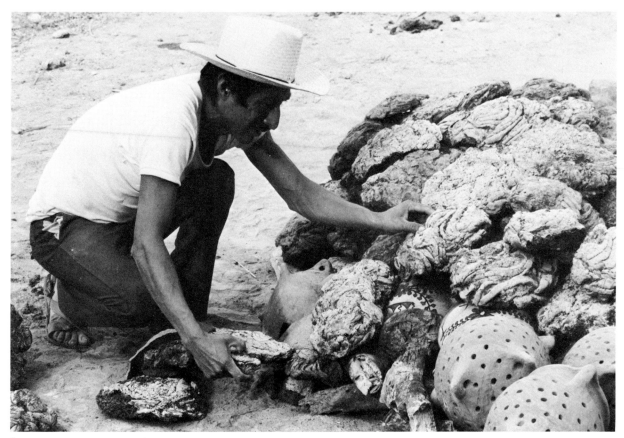

6.

Figure 4. As the reeds burn down and turn black, more ashes kept at hand in jars and cans are added to the pile to keep the wind from reaching the pots. A *petate* brought from the sleeping quarters is used to shield the fire from the breeze. Toward the end of the firing, small holes are opened in the ashes and a few pieces of kindling carefully inserted to insure a complete burn. Zipiajo, Michoacán, 1973.

Figure 5. Customs vary. Although in other sections women may be the potters, in this section of Guerrero men occasionally assist by decorating a pot or two, and in digging the clay, gathering fuel, and firing the wares. Francisco Pastor (foreground) and members of his family, Zumpango del Río, Guerrero, 1972.

Figure 6. Science and lore blend in the manner in which each pot and each fragment of fuel is placed. In Zumpango well-dried wood and sun-baked cow manure are used. Francisco Pastor, Zumpango del Río, Guerrero, 1972.

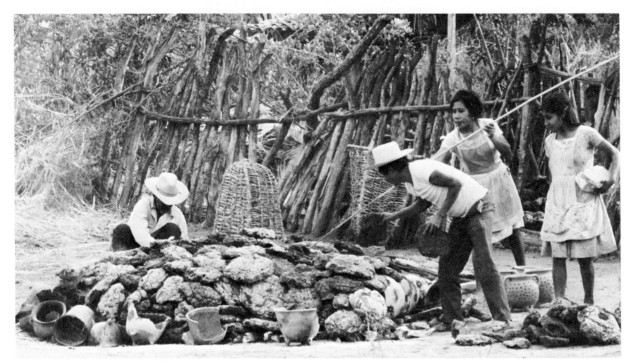

7.

8.

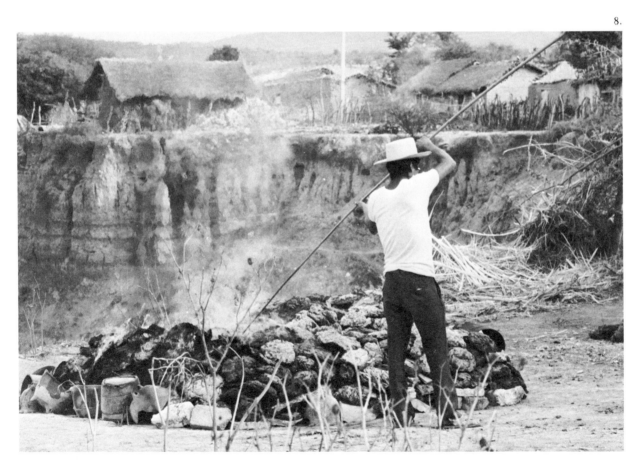

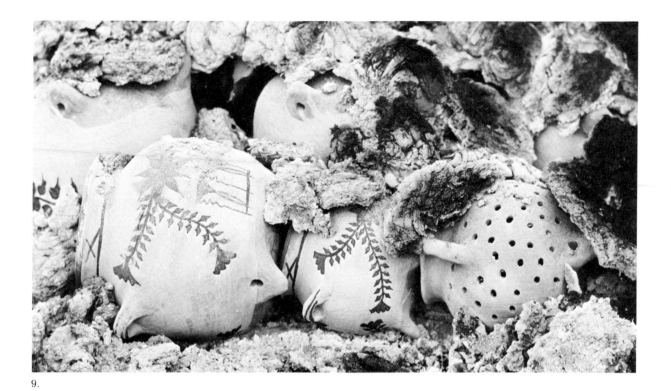

9.

Figure 7. The pasture platters are carefully placed on top with a long pole. (Earlier the men have hauled the fuel from nearby trails in the willow reed baskets seen in the background.) The Pastor family, Zumpango del Río, Guerrero, 1972.

Figure 8. More fuel may be added to cool spots as the fire works its way from one side to the other. Old broken pots ring the mound to prevent unwanted drafts. A member of the Pastor family, Zumpango del Río, Guerrero, 1972.

Figure 9. When the embers die, little ash and even less charcoal are left. Zumpango del Río, Guerrero, 1972.

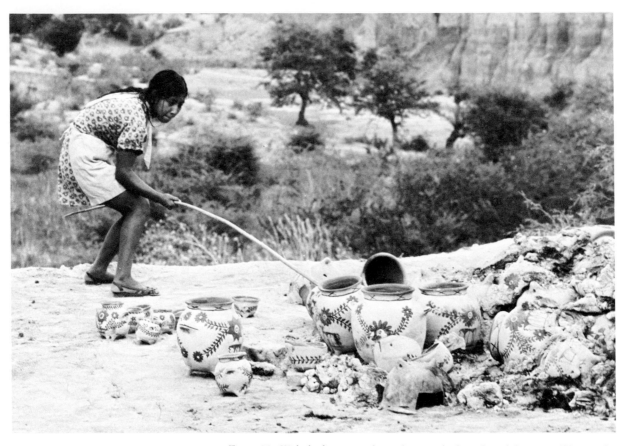

Figure 10. With the fire not yet burned out on the far side and the pots still hot on the near, inspection begins. This firing proved successful, with not a single loss out of the 75 to 100 pieces fired. The first photograph (no. 5) in this sequence was taken at 3:45 P.M. and the last shortly after 5:00 P.M. A member of the Pastor family, Zumpango del Río, Guerrero, 1972.

The Open-Top Kiln

The crude and primitive kiln design brought to the New World by the early Spaniards represented a technological advance over the open fire, since temperatures of around 900°C could be attained with it. This style is variously known as the Moorish, Arabic, or Mediterranean kiln, but we prefer to call it the open-top kiln (Figure 11). Common throughout Mexico, these kilns are brick, adobe, or even rubble tanks with some type of grate dividing the tank into a lower firebox area and an upper stacking or "pot" chamber.

8

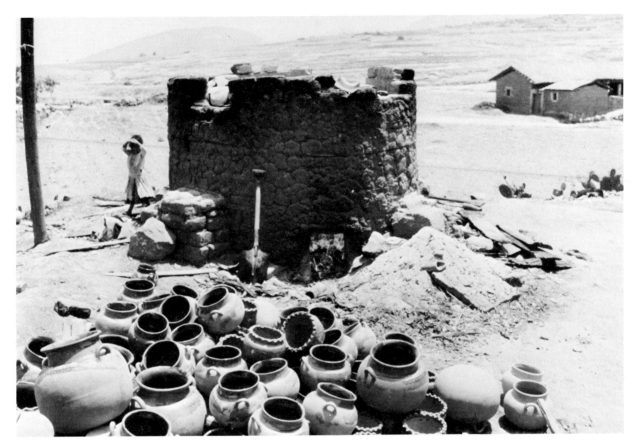

Figure 11. The preponderance of Mexican kilns are still built on the fundamental principles brought by the earliest Spanish settlers—essentially a firebox and an upper stacking chamber. Temascalcingo, State of Mexico, 1971.

The open-top kiln is a simple updraft ceramic firing system. Briefly, heat released by combustion is carried circuitously upward by gases rising through the spaces between tightly packed pieces of pottery. Gradually the wares absorb this gas-transported heat until the temperature of the clay is high enough to cause certain chemical reactions. This strengthens and hardens the clay. If the heat flows too rapidly past the wares, as in the case of a loosely stacked kiln, the clay does not absorb enough heat to raise its internal temperature. Simply stated, the wares in an open-top kiln act as a heat filter.

The type of fuel is of little consequence so long as adequate heat is released. Most Mexican potters prefer wood. In some sections, however, wood is becoming increasingly scarce, and potters are forced to use whatever is

9

available, even, if need be, old rubber tires (Figure 12). Most wood substitutes are those which can be handled in the same fashion as wood; for instance, a variety of dried cactus is used in semiarid parts of Puebla. Vines, brushes, grasses, and cow manure are also used. Fuel oil and kerosene are effective fuels, but since they require a complicated and expensive burner system, they are impractical for many Mexican potters, particularly those in out-of-the-way areas. Still, a few have successfully converted to oil.

When we inquired about the length of time necessary for firing, almost without exception the answer was vague: "not long," "half an hour," or "a few hours." Lacking a watch or a clock, most potters simply estimate. Our own observations led us to conclude that the time required to fire the open-

Figure 12. While most potters prefer wood, many are being forced to substitute, or at least supplement, their scarce wood supply with other fuels. Old tires chopped into small pieces make an effective, though somewhat smoky, fire. *Casa Escárcega*, Metepec, State of Mexico, 1971.

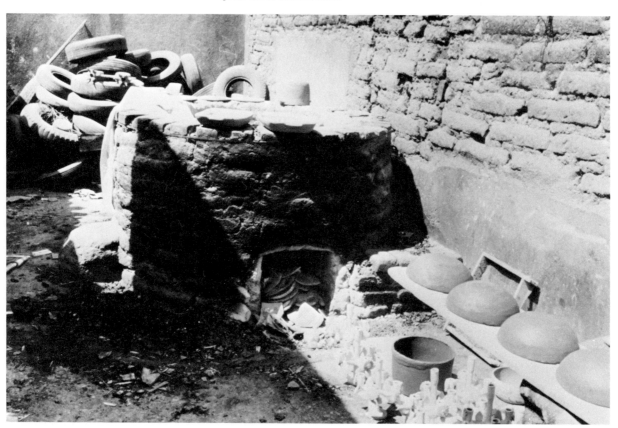

top kiln was indeed short: kilns of average size take two to three hours, but some are fired in less than an hour, and others in five or six. The time, of course, depends upon the amount and type of pottery being fired, the efficiency of the kiln and the fuel, and the potter's experience and know-how.

Open-top kilns vary greatly in size, but, in general, potters who make large pieces build large kilns (up to three or four meters in diameter) and those who make small pieces or toys use miniature kilns (Figure 13). The diameter of the average-sized open-top kiln measures between one and two meters.

There are endless mutations on this style of kiln. In Tehuitzingo, Puebla, rubble kilns without a firebox are found, the barest step beyond the pre-

Figure 13. Massive kilns are used for massive pieces. Each of these *chimeneas*, or portable fireplaces, averages forty-five centimeters in diameter. Tonalá, Jalisco, 1971.

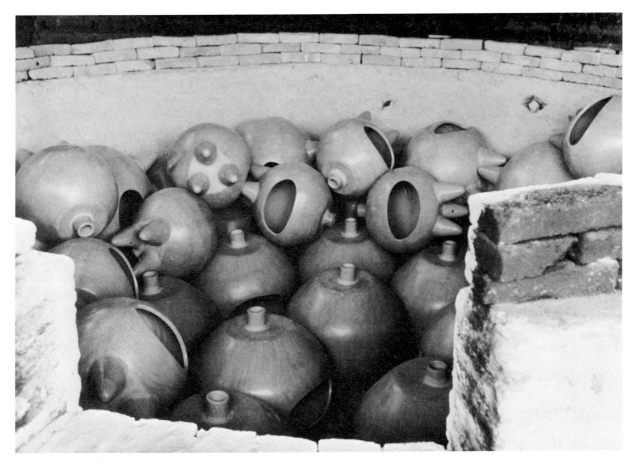

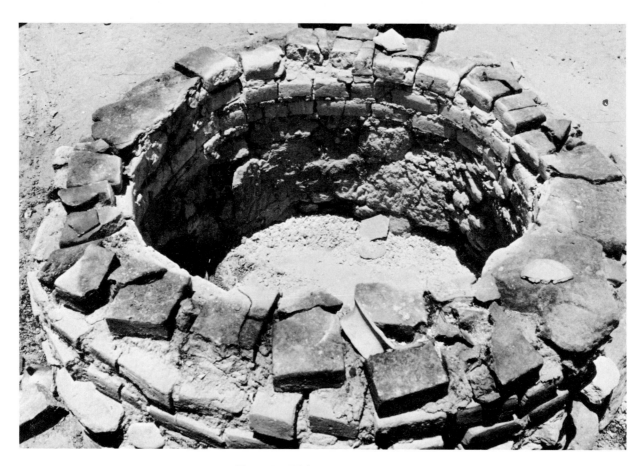

Figure 14. While some people have resisted all European concepts, others, either by intent or by misunderstanding, have only partially accepted the idea of kilns. A rubble wall ringing the pottery helps contain the heat of an open fire and, in the evolution of kilns, may be seen as the first step. Since there is no firebox, fuel will be carefully fed through fireports in between the pottery to be stacked inside the rubble ring. Tehuitzingo, Puebla, 1971.

Conquest open firing (Figure 14). Only a few kilometers south of Tehuitzingo, in Acatlán, Herón Martínez Mendoza on occasion constructs special kilns for special pieces. Commissioned by the wife of the president of the Republic to make a gigantic tree-of-life, he built one such kiln, of typical Mexican design, brick ring by brick ring, around the tree as it was being made. During the construction each ring served as a scaffolding, and after the tree had been fired, the kiln was gradually torn down, the separate rings again providing a scaffolding for Señor Martínez to paint the tree in brilliant

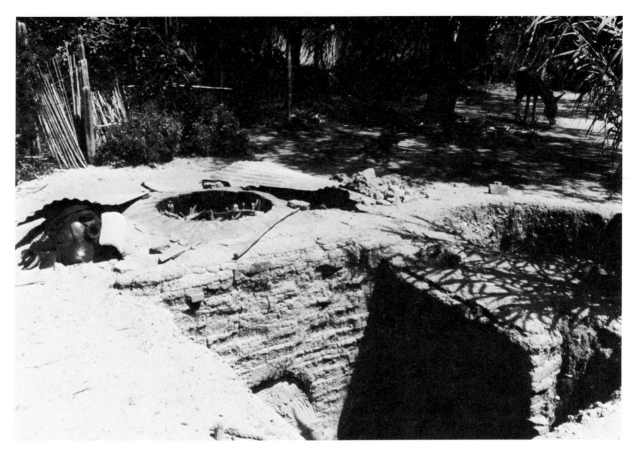

Figure 15. Although the principle behind all open-top kilns is the same, regional stylistic differences exist. For example, the kiln may be totally above ground, partially buried with its firebox below ground, or completely subterranean with the kiln top at ground level. Stoking pits dug alongside such subterranean kilns provide access to the fireports. Subterranean kilns are easily sealed with damp earth for smudging, a process needed to produce Coyotepec's black wares. San Bartolo Coyotepec, Oaxaca, 1971.

colors. Alfonso Soteno Fernández of Metepec, who also makes monumental pieces, fires the same kiln over and over again. Guy wires attached to the kiln's interior walls support the work as it is being constructed.

While most kilns are entirely above ground, variations range from partially buried kilns, with the firebox below the ground, to the completely subterranean kilns of Coyotepec, with the tops at ground level (Figure 15). In these buried and half-buried kilns, pits dug alongside furnish access to the stokeholes.

13

Other Kiln Styles

Although the open-top kiln is the most frequently used, Mexican kilns are not limited to this style. In the high mountainous regions of the State of Puebla, in Aquixtla and neighboring communities, an unusual partially domed kiln is found (Figure 16). And in the capital city of Puebla, progressive potters kept pace with their European counterparts by introducing

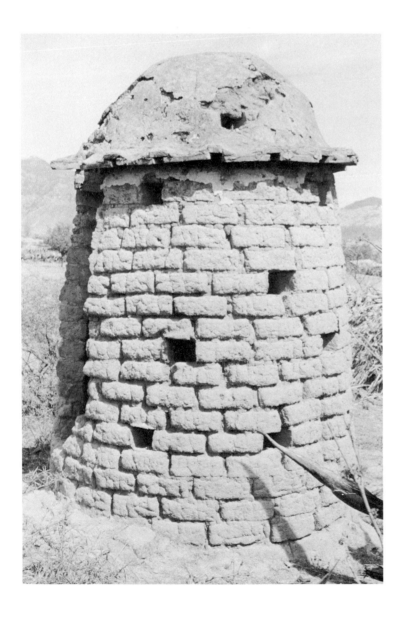

Figure 16. We tried, without success, to trace the origin of the domed kilns of mountainous northern Puebla and were told repeatedly that this kind of kiln "has always been used here"—at least within living memory. Taller than the usual open-top variety, these kilns have perforations in the walls, which provide adequate draft. The holes are also used as stokeholes. Through them pine so resinous as to be nearly explosive is fed near the end of the fire, providing the sudden burst of heat needed to bring the kiln up to peak temperature. Aquixtla, Puebla, 1973 (Summer rains take their toll, and the kiln must be repaired each year.).

large and more efficient bottle kilns, so named because of their shape (Figure 17). At least one plant in the city of Oaxaca uses a multichambered kiln, the upper chamber for bisque (the first, unglazed firing) and the lower for the glaze firing. In Dolores Hidalgo, Guanajuato, after observing tile-stacking in a square, but otherwise traditional, open-top kiln at one factory, we were amazed to find a large modern production tunnel kiln in a second.

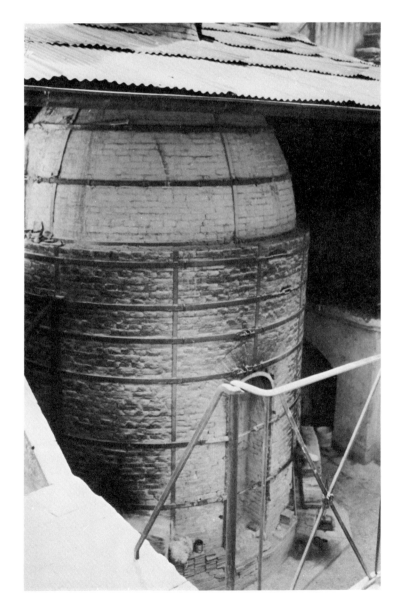

Figure 17. While the "typical" Mexican kiln is open-top, here and there kilns of updated design have been in use for some time. In Puebla, the Talavera plants adopted the "bottle kiln," popular in Europe during the nineteenth century. This kiln is worthy of its European counterparts, standing more than five meters high from the base to the start of its bottle-shaped dome. *Fábrica de Isauro Uriarte B.*, Puebla, Puebla, 1971.

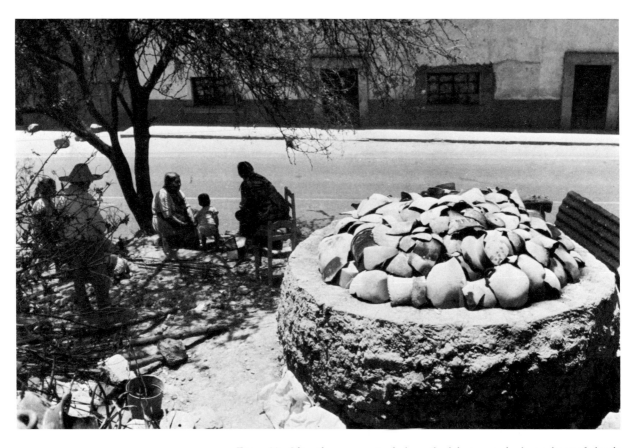

Figure 20. Often the wares extend above the kiln top, and when a layer of shards covers it, the kiln resembles a slightly overstuffed trash barrel topped with broken crockery. Zinapécuaro, Michoacán, 1971 (Señora Rosa Barrera, her grandson, and Emily Cumberland Whitaker in the background).

layer of pots begins to glow faintly with the color of black cherries or oxblood (Plate 1), and at this point there is often an accumulation of soot on the covering shards. A few slivers of resinous kindling tossed on top causes a brief flareup, burning off the soot, and the firing is then complete (Figure 22). Often any fuel remaining in the firebox is quenched at this time and saved for the future. The entire firing procedure is totally determined by the experience—the eye—of the potter, and only in shops and factories with more sophisticated equipment are pyrometric cones or pyrometers used.

The same general procedures of the bisque fire are used for the glaze fire, but the wares must be even more carefully placed. Hot glaze is molten glass, and where a glazed surface touches a second surface, glazed or not, the two adhere. Very small fused areas may be snapped apart with little damage to

Figure 21. Stacking practices vary greatly, depending on the type of kiln and the nature of the ware. Perhaps one of the most amazing things we saw in Mexico was a workman walking on top of the first layer of greenware in order to position subsequent layers. *Alfarería La Azteca*, Encarnación de Díaz, Jalisco, 1972.

the pieces, and much Mexican pottery has tiny chips caused by this stacking method. These scars are generally not considered defects.

Since flames as well as smoke and other hot gases come into contact with the ware, firemarks frequently occur. Many times these blemishes, particularly on unglazed ware, enhance the beauty of the individual piece, though most potters attempt to prevent them.

There are many variations on these stacking and firing procedures, the most notable of which are those of San Bartolo Coyotepec and Santa María Atzompa in the State of Oaxaca, and of the city of Guanajuato. For many years the village of Coyotepec has produced the famous burnished "Oaxaca

19

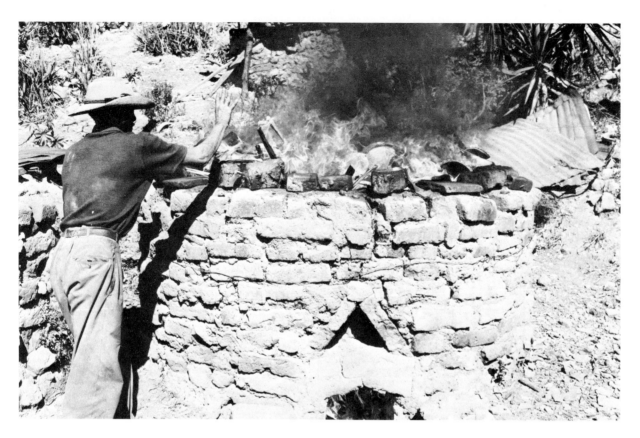

Figure 22. When the heat saturation point is achieved and the pots beneath the covering of shards take on a faint incandescent glow, a few slivers of *ocote*, a resinous wood, may be tossed on top. This volatile wood immediately bursts into flame, burning off accumulated soot from the upper pots, and the firing is complete. Zinapécuaro, Michoacán, 1973.

blackware," and in recent years this blackware has been copied in such other regions as Acatlán in Puebla, Metepec in the State of Mexico, and Tzintzuntzan in Michoacán. Despite a carefully nurtured Coyotepec myth, there is nothing unusual or mysterious about the technique of producing blackware. It results from a firing process best described as "smudging." Toward the end of the firing, the potter adds fuel which will produce a great amount of smoke, and he then seals his kiln completely, usually by shoveling damp earth over the top and the stokeholes. The result is a black, carbon-saturated ware. (Technically speaking, this black color is not the result of "reduction"; that is, the introduction of carbon monoxide into the kiln to reduce the oxygen ratio of the minerals in the clay, thus changing the red iron oxide to black iron oxide. While this may occur to a degree, the black color is

primarily free carbon impregnating the ware. Reduction per se does not leave carbon present.)

In Atzompa, removing the pots from the kiln is an uncomfortably hot operation. Using metal hooks fixed to long wooden poles, potters carefully lift out each piece while the glaze is still molten, thus preventing the pieces from fusing. And in the section of the city of Guanajuato known as San Luisito, a technique comparable to the Japanese *raku* is used: glazed bisque ware (in this case only the interior is glazed) is inserted into a red-hot kiln and left just long enough for the glaze to melt. A load of teapots took about five minutes. The still-glowing pots are removed immediately and then set aside to cool within seconds.

Thermal Shock Resistance

To the U.S. potter the most astounding quality of Mexican pottery is its ability to withstand sudden changes in temperature, for many Mexican cooking vessels may be used as "flameware." That is, they may be placed directly over flames of wood, charcoal, or gas and will not crack. It is usually assumed that this thermal shock resistance stems from some inherent characteristic of the clays. The fact is, however, that pots made of clays from widely separate geological formations and with great variations in chemical and physical properties share this quality. The resistance to thermal shock comes from the methods of preparing and firing the clay. The pottery's soft porous quality and the relatively low temperature at which it is fired are critical. In addition, the Mexican potter fires his wares much more rapidly than does his counterpart in more technologically advanced countries.

The Future of Mexican Pottery

Many people concerned with the survival of Mexican ceramics believe that improvement of kilns is the pivotal problem. The open-top kiln, considerably more efficient than open firing, raises the maximum firing

temperature by at least 200°C. Another increase of 50° to 100°C would greatly simplify the problem of fitting a leadless glaze. But it would mean the sacrifice of Mexican pottery's most important quality, its thermal shock resistance.

Various kiln modifications are possible, and both individual potters and officially sponsored programs are attempting to improve kiln design. To alien ceramists, accustomed to roofed-over kilns, the simple corbeled dome seems an obvious solution. In Metepec, where open stacking (more spaces between pieces) is required for such works as the giant trees-of-life, some enterprising potters have begun to cap their kilns with corbeled domes (Figure 23). (These funnel-shaped tops are lately come to the village, and each potter we talked to claimed credit for their innovation.)

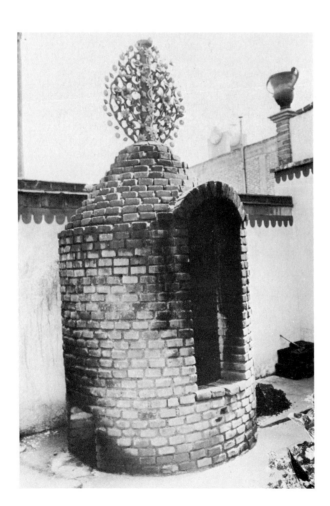

Figure 23. Improvement of kilns is crucial to the survival of Mexican pottery. Some potters attempt to meet their own needs by such solutions as corbeled domes over otherwise traditional kilns. *Taller de Heriberto Ortega*, Metepec, State of Mexico, 1972.

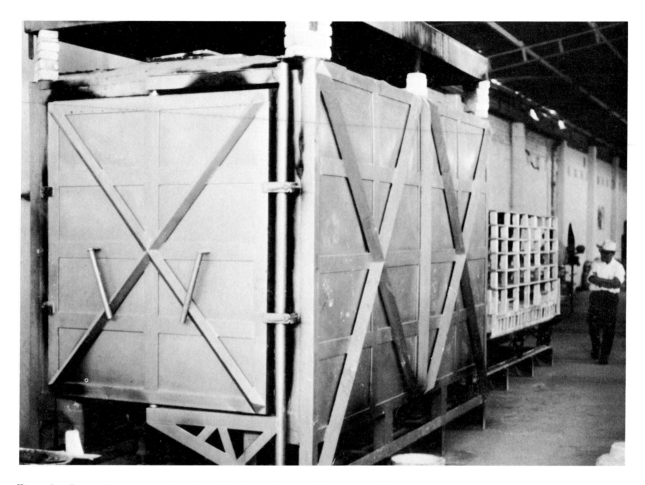

Figure 24. Some potters are experimenting with minor changes in their open-top kilns, adding domes or petroleum burner systems. Most of these efforts are motivated by the desire to find more economical ways of firing their customary wares. But a few progressive potters, working with little or no outside help, have designed and built modern gas-fired kilns such as this two-car shuttle kiln. *Alfarería Guerrero*, Dolores Hidalgo, Guanajuato, 1971.

Other progressive potters, such as Fortino Guerrero of Dolores Hidalgo in Guanajuato, have successfully constructed modern gas-fired kilns, with little or no outside technical assistance (Figure 24). Still others have experimented with electric kilns, but most voice discouragement because of frequent power failures and high costs.

One of Mexico's most imaginative potters, Jorge Wilmot of Tonalá, takes

23

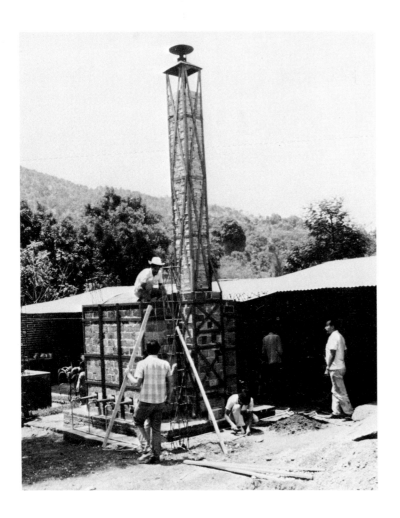

Figure 25. A number of private and government-sponsored projects are trying to upgrade Mexican pottery. In Valle de Bravo high-temperature kilns have been constructed and scientifically trained ceramists employed to instruct local potters in new techniques. Unfortunately, it is still too early to evaluate fully the impact of these programs. If successful, they will drastically alter the character of Mexican pottery. Valle de Bravo, State of Mexico, 1971.

yet another approach. Wilmot, known throughout Mexican and U.S. pottery circles for his distinctive stoneware, uses a typical open-top kiln for his bisque fire and a modern high temperature kiln for his final glaze fire. Wilmot's acumen as an artist, ceramic technician, and businessman bolsters our own conclusion that a tightly packed open-top kiln can prove both efficient and economical for low-temperature wares.

In the Valle de Bravo and Temascalcingo areas, the State of Mexico is sponsoring a radical departure from the region's traditional firing methods, and has brought in "experts" from Mexico City and Japan to supervise experimentation with high-temperature kilns (Figure 25). It is perhaps too early to evaluate these undertakings, but we believe that the slower trial-and-error efforts at self-help have greater chance of success than such government-run programs.

2

The Clay: Its Forming and Finishing

Among potters there is a clear distinction between "clay" and "clay bodies," although the shorter term "clay" is applied to both. Actually, clay is a specific group of minerals whose most notable property is plasticity, an ability to take a shape under pressure and retain that shape after the pressure is released. A clay body, on the other hand, is a mixture of minerals, partially clay, with the remainder composed of other nonplastic materials which contribute different forming and firing properties. For example, pottery made from pure clays such as kaolins or ball clays tends to shrink excessively both in drying and firing. The result is that a piece made of pure clay may shrink to less than three-quarters its original size. Moreover, such pots are difficult to dry and fire without cracking, and they develop little strength, even when fired to white heats in modern high-temperature kilns. For these and other reasons, potters, wherever they may be, usually combine various minerals (and sometimes organic materials) to form a clay body which is suited to their production methods.

It is relatively easy for the U.S. potter, using commercial materials for which there is much technical information, to compound a clay body suitable for his particular needs. His job is further eased by the quality control measures employed by large ceramic supply houses, which ensure uniformity, batch after batch, year after year. For most Mexicans this is not the case.

The Mexican Clay

As a rule, Mexican potters do not use commercially refined clays. Like their forebears, they dig their own clay from the surrounding countryside or from community-held property, and in some areas they continue to mine the same veins as did "the ancient ones." Private ownership of clay mines is of recent origin; only a few potters own their own deposits. In recent years some landowning potters with large deposits of good clay have found it more profitable to supply clay to others than to make pots, and although most Mexicans do not accept the U.S. equation that time equals money, the advantage of clay delivered to the door by burro or truck is worth the small additional cost (Figure 26).

Few potters buy or mine more than a minimal supply of clay, enough for a few days or a week at most. This is partly because of limited storage facilities, and partly, a philosophy of living one day at a time. In Tonalá in the State of Jalisco, for example, the father or eldest son usually mixes the family's clay supply each day before breakfast, allowing it to "repose" an hour or so before use. Any clay left over at day's end is left to dry and then prepared again the following morning. In other areas enough clay to last several days may be prepared, even aged for two or three days. But the prolonged storing or aging of moist clay, a common practice in China and Japan and other countries with long ceramic traditions, is rarely seen in Mexico. Otherwise, the Mexican potter, though he may vary in details, follows the same basic principles in preparing clay used by his fellow potters throughout the world.

Fresh from the mine, clay is lumpy and contaminated with roots and stones, and it must be rendered into a smooth, doughlike, plastic mass before it can be worked. There are two methods by which this is accomplished. The first, historically used by Mexico's Indians, compares roughly to grinding corn and then mixing it into dough for tortillas. The second method, introduced by the Spaniards, may be likened to concocting a soup purée and then reducing it to cream cheese consistency by partial drying in brick-lined beds (Figures 27, 28). The Indian technique offers the advantage of rapidity, for within ten minutes the clay may be ground, mixed, and used. The Spanish

26

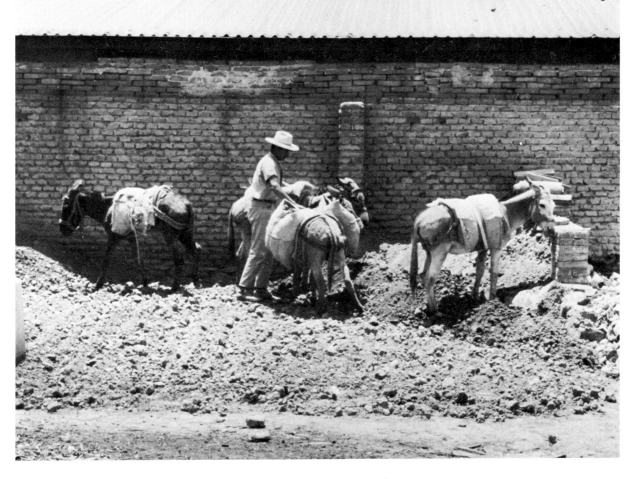

Figure 26. Clay, fresh from the mine, is delivered to the potter's patio. *Alfarería de J. Cruz Rodríguez Hernández*, Dolores Hidalgo, Guanajuato, 1971.

preparation is slower, but the clay body develops greater plasticity, a quality which is essential for "throwing," or forming a vessel on the potter's wheel.

In both cases the rainy season presents serious problems. Pulverizing damp clay is nearly impossible, and only a few Mexican potters are affluent enough to afford a covered storage shed (Figure 29). In the Spanish method, the drying beds are exposed to the rains. Pottery making for most Mexicans is a home occupation, and the clay is usually dried and pulverized on the family patio, the sidewalk, or the street in front of the house. Summer rainstorms

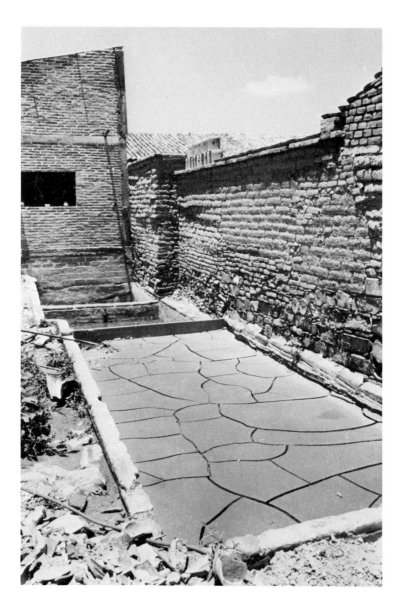

Figure 27. The "slip" method of preparing clay, which was introduced by the Spaniards, follows time-honored procedures used in Europe and the Far East. Slaked and stirred in the first tank, the soupy clay is screened into a second. After standing a few hours, the excess water is decanted, and the remaining slip is bailed into shallow brick-lined drying beds, where it remains until stiff. Dolores Hidalgo, Guanajuato, 1971.

Figure 28. Larger shops may devote extensive patio space to slip tanks and drying beds, but the smaller shops make do with an old *cazuela* or two and a few old bricks. Dolores Hidalgo, Guanajuato, 1971.

Figure 29. Few potters prepare or store more clay than is needed for a few days. Some affluent families, however, do build storage sheds and devise machinery to lighten the clay-preparing chores. Here a piece of farm machinery has been converted into a clay grinder. *Alfarería de Modesto Reyes Quiroz,* Valle de Bravo, State of Mexico, 1971.

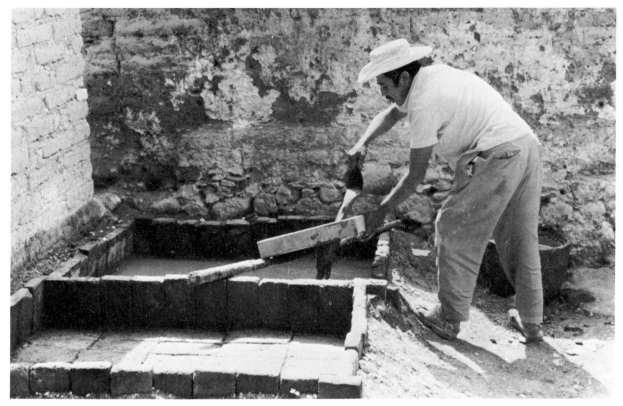

28.

29.

are occasions of great family activity; all hands rush to gather the nearly dry clay, like midwestern farm wives scurrying to bring in the wash at the start of a sudden thundershower. As the rains increase in intensity and become daily occurrences, all pot making subsides, only to be resumed months later when the showers abate. In Mexico when the rains come, the land is tilled and the maize grown, while the long hot days of the dry season are devoted to pottery making.

In addition to the differences stemming from tradition, there are regional distinctions in pulverizing methods. These are due mainly to the types of clay available and the degree of fineness necessitated by the pottery style. Interestingly, the three most common pulverizing tools are pre-Hispanic. If not too fine a grain is desired, large amounts of clay may be quickly crushed by pounding with a wooden bat (Figure 30); a finer grain may be achieved with the "rocker stone" (in size and shape much like a large watermelon) by rocking and rolling the stone over the lumps. But an even finer grain is produced by pulverizing on the indigenous corn-grinding metate (Figure 31). After grinding, unwanted coarser particles are removed from the powdered clay by winnowing (air-floating, as in removing grain from chaff) or by sifting through metal or cloth screens.

Some clays are "natural" bodies and contain all the ingredients necessary for pottery. Others must be "opened up" or made more porous by adding nonplastic materials. (Although ceramists seldom use the term, anthropologists and archaeologists call these materials "tempers.") As elsewhere, in Mexico the mixing of clay varies enormously, but the most common practice is to mix a plastic black carbonaceous clay with a smaller amount of a gritty, less plastic, white clay (Figure 32). In some instances, carefully selected fine sands, crushed potsherds, or even such organic materials as cattail fluff or cotton lint are mixed with the plastic clay.

Though the potter may be adept at judging the necessary amount of nonplastic materials, occasionally he may make a mistake. Variations in clays, even those coming from the same vein, must be taken into consideration, and the balance between the plastic and nonplastic materials adjusted accordingly. A miscalculation invites disaster, with the pots cracking during drying or firing.

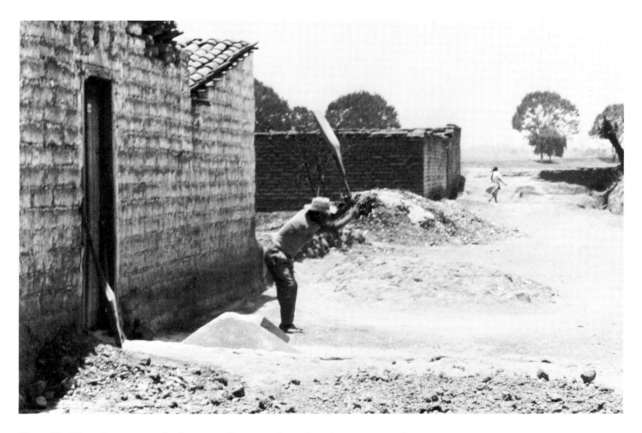

Figure 30. The indigenous wooden bat is an effective tool, crushing large amounts of clay quickly. Unwanted coarse particles are sifted out. Outside the pottery workshop of Manuel Estrada, Metepec, State of Mexico, 1971.

Figure 31. When required, a finer grained clay may be prepared by grinding on the *metate*, the ubiquitous corn-grinding implement of Mexico. *Casa Ramírez*, Santa Fe de la Laguna, Michoacán, 1971.

32.

Hand Forming

In many areas of the world handcraft heritages are the last link in a long evolutionary chain, but in the case of Mexican ceramics, past and present are inextricably interwoven. This is clearly seen in pre-Hispanic forming methods which twist their way between the more recent threads of both colonial and modern origin.

Direct hand modeling of ceramic forms remains unaltered after hundreds of years in such places as Amatenango del Valle, Chiapas; Zumpango del Río, Guerrero; and Blanca Espuma, Veracruz; though modeling techniques differ by area (Figures 33–35). These range from pounding and stretching a single lump of clay into an enormous water storage jar to laboriously constructing a huge stewpot by placing clay coil upon clay coil. In hand modeling the potter rotates his pot, which has been placed on some type of support—a leaf, a cloth, a board or a mold. In the case of a large piece he may find it easier simply to walk around the piece as he forms it (Figures 36–38).

Figure 32. Once ground, the clay still has to be mixed, usually by hand or foot. Here a two live-horse merry-go-round performs this task. Rancho Nuevo, Veracruz, 1973.

Figure 33. In some areas tenacious traditions persist. Forms, decorations, techniques, and even degree of skills have scarcely changed in five hundred years. Amatenango del Valle, Chiapas, 1973.

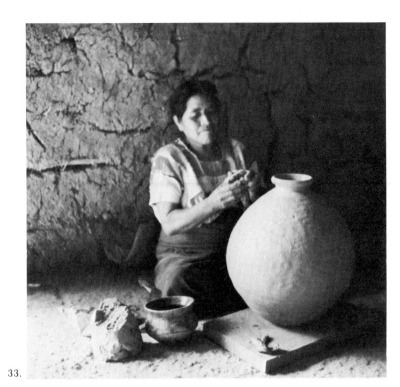

33.

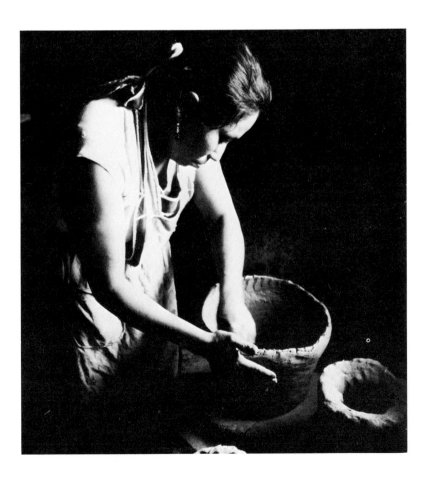

Figure 34. In other places some changes have taken place. Pots are now fired in kilns rather than in open fires, but the mastery of hand-building pottery is still passed down from mother to daughter. The daughter, however, may prefer to work at a table rather than sit on the floor as did her mother. Blanca Espuma, Vera-cruz, 1973.

33

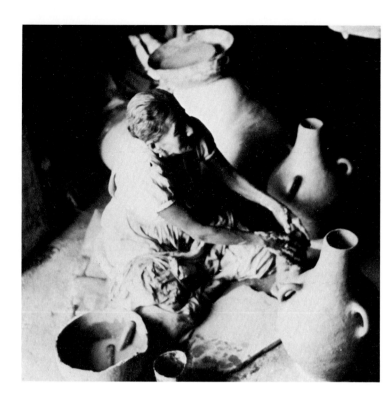

Figure 35. Between other household chores, the mother-daughter team can complete a dozen or more large pieces daily during the dry season. The daughter forms the lower half, while her mother finishes pieces begun the previous day. Blanca Espuma, Veracruz, 1973.

Figure 36. Various combinations of techniques are frequently used in conjunction with molds, especially with larger pieces. In this case a single coil will eventually increase the size of this *cazuela* by several litres. Metepec, State of Mexico, 1971.

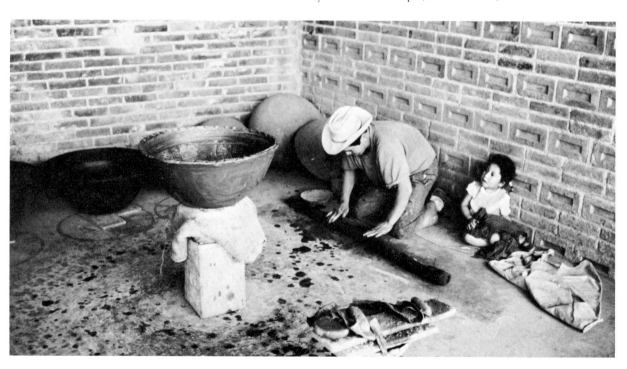

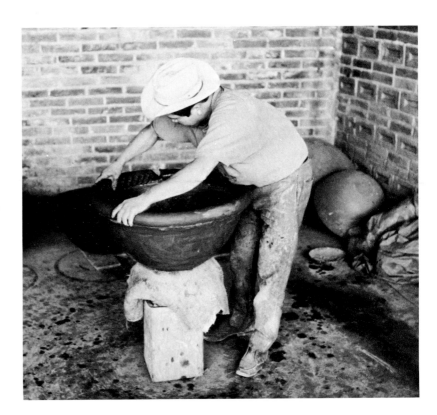

Figure 37. Rhythmic pinching joins the coil to the rim. Metepec, State of Mexico, 1971.

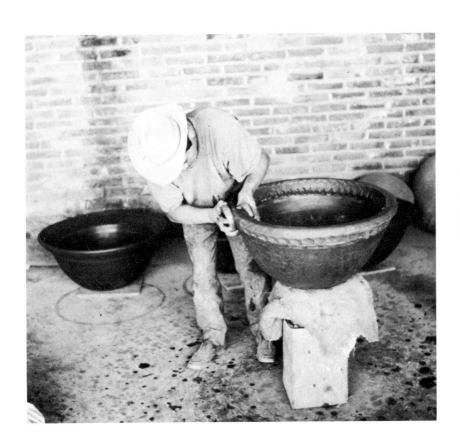

Figure 38. Continuing in cadence, the worker walks around the clay, hammering and stretching it into final shape. When smoothed, it will be a larger version of the *cazuela*. Metepec, State of Mexico, 1971.

Wheel Forming

True turntables and potter's wheels were unknown in pre-Conquest Mexico, but a device known as the *kabal*, and attributed to the Maya Indians, dates back a thousand years. Simply described, the *kabal* is a turntable without a fixed pivot. Variations on this mechanism are common in the State of Oaxaca, particularly in the villages of Coyotepec and Atzompa, where they are known as *platos* (plates) or *moldes* (molds) (Figures 39, 40). In Acatlán, Puebla, another variant of this device called a *parador* is used.

To the south of Coyotepec and Atzompa, in the Isthmus of Tehuantepec, the Indians of Juchitán adopted the hand-turned or "slow wheel" brought by the Spaniards, but they seldom used the faster-turning European kick wheel (Figure 41). As a rule, both the *kabal* and the slow wheel are turned by hand, but some potters prefer to turn them by foot. In Juchitán potters have developed amazing speed and dexterity in manipulating the slow wheel. In other areas of Mexico foot-turning by women is considered immodest because of the indecorous legs-akimbo position.

Legend credits the Father of Mexican Independence, the priest Miguel Hidalgo y Costilla, with the introduction of the potter's wheel to portions of the State of Guanajuato at the end of the eighteenth century, but Spanish colonials had brought it to other areas as early as the sixteenth. These crudely made wheels were constructed almost entirely without metal. Nearly identical wheels may be found in use today, although, usually, the design has been slightly updated. Despite the rude quality of these wheels, Mexican potters attain unbelievable skill in their use, often throwing several small bowls per minute (Figure 42).

Molds

The use of molds for forming pottery and other clay objects is of very ancient origin in Mexico. Pre-Hispanic molds were made of wood or, more commonly, of unglazed fired clay (bisque). Today, at many a Mexican archaeological site ingratiating vendors approach the tourist offering to sell

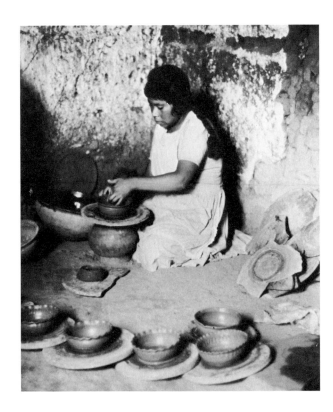

Figure 39. Some become proficient in the ancient Mayan method of making pottery in their early teens. Although the pot may be spun at up to twenty revolutions per minute in finishing off the rim, the motor skills used in the *kabal-parador-molde* forming method are more allied to hand-building than throwing. Señorita Oliva López Ruiz, Atzompa, Oaxaca, 1971.

Figure 40. Many potters remain active for two-thirds of a century, and their skill increases with experience. A correlation frequently exists between age and the size of the piece. Señora Maura Domínguez, Coyotepec, Oaxaca, 1971.

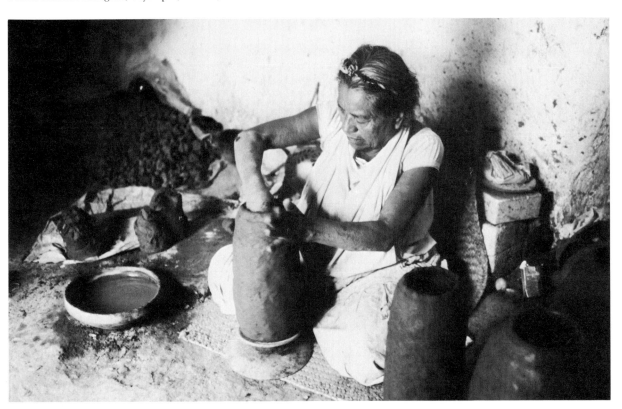

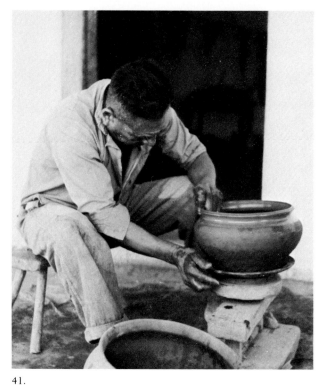

Figure 41. The "slow wheel" brought to the Isthmus of Tehuantepec by the early Spaniards is used by both men and women. While the Zapotec Indians of this region were able to make the transition to the fixed-pivot slow wheel, they have never found the faster kick wheel acceptable. Still, a piece of this size is formed in less than five minutes. Juchitán, Oaxaca, 1973.

Figure 42. The European kick wheel, which came to Mexico in the sixteenth century, remains the tool of the more Hispanicized areas. Many Mexican throwers produce at incredible speeds, often several pieces per minute. A great variety of throwing techniques are used, ranging from the "off the hump" method shown here, to the "coil and throw" method in Encarnación de Díaz, Jalisco. This worker is throwing an incense burner. *Alfarería Gerónimo Alonso, Barrio de la Luz,* Puebla, Puebla, 1971.

41.

42.

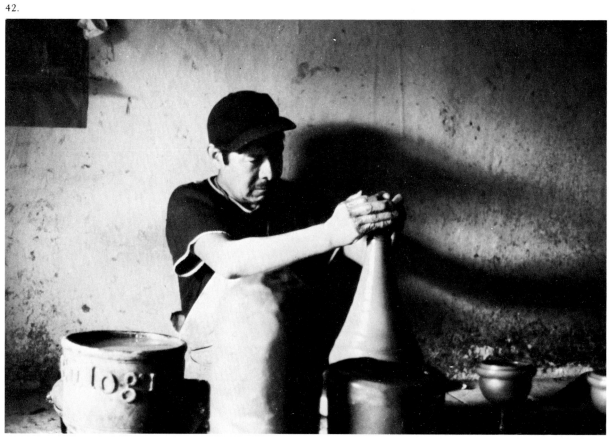

him authentic idols. Some of these idols, in fact, are only half fake; they have been recently formed in pre-Hispanic bisque molds unearthed in nearby cornfields or some unguarded archaeological dig. At the height of the excavations of the 1940s and 1950s, exuberant archaeologists identified some of their finds as thick-walled pre-Columbian bowls. Time and additional data have proved these vessels to be nothing more than simple bisque molds for forming pottery. Similar molds, only slightly modified, are still made and used extensively throughout central Mexico.

Plaster molds frequently used in the United States are a twentieth-century innovation. While they are finding increasing popularity throughout Mexico, they are used in the traditional manner, i.e., with plastic clay as press molds. The mass production method of "slip casting" is rarely seen in Mexico except in the industrialized plants in Monterrey, Mexico City, and a few isolated smaller plants (which produce wares that are virtually indistinguishable from those of U.S. roadside shops).

Bisque molds are generally preferred. A few potters specialize in making bisque molds for sale to other potters. Sometimes the number of molds they can afford to purchase limits the type and amount of a family's production. In other cases, influenced by custom and heritage, a family may confine its output to a single form. (A potter friend of ours in Capula, Michoacán, has been making identical simple cups for more than fifty years, never once varying the size or shape.)

Both concave and convex molds, as well as multiple- and single-piece molds, are indigenous to Mexico. According to University of California anthropologist George Foster, however, two mold innovations have come to Mexico since the advent of the Spaniards. First, two-piece molds with a vertical seam were not used in pre-Hispanic Mexico and were, therefore, presumably brought from Spain (Figures 43, 44). Second, handles were added to the convex horizonal molds, giving them the appearance of mushrooms. Foster says the "mushroom molds" appear to be a post-Conquest but indigenous invention (Figure 45).

It is also interesting to note that the *tortillas de varro*, or slabs of clay, used for pressing into or over the molds continue to be "batted out" with a pre-Hispanic tool, and that the "rolling pin" technique widely used in Europe and the United States is rarely employed (Figures 46–48).

39

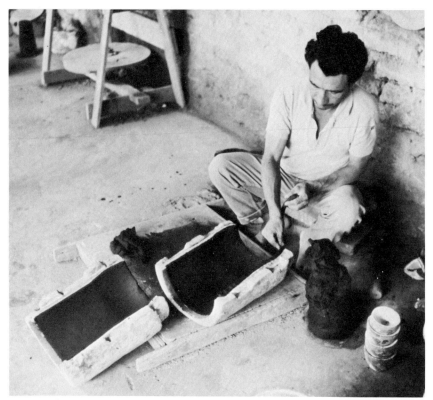

43.

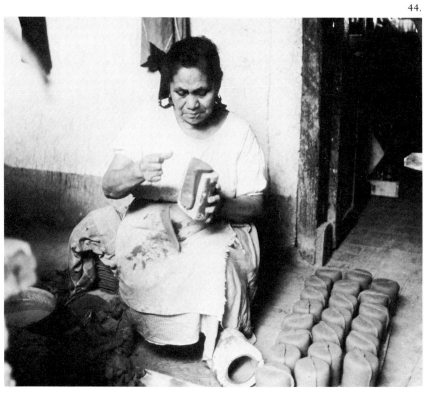

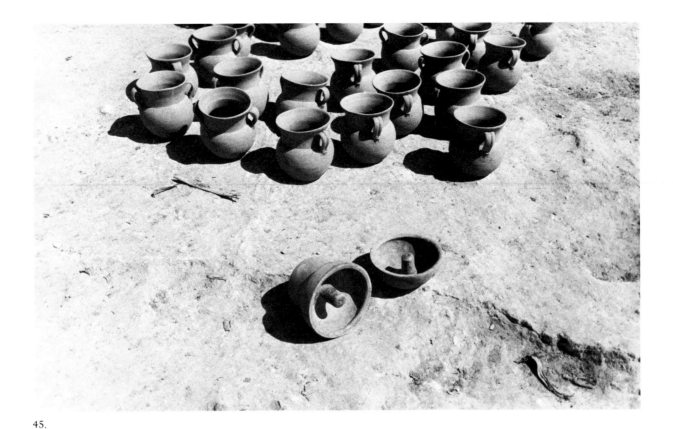

45.

Figure 43. While the Conquest ushered in the vertical seam mold, the use of plaster molds is a twentieth-century innovation. The potter's wheel shown here is used solely as a lathe for making plaster molds. Workers in the pottery shop of José Bernabe, Tonalá, Jalisco, 1971.

Figure 44. Surplus clay is trimmed from the mold, usually with a string held taut between thumb and tooth. *Alfarería de Modesto Reyes Quiroz*, Valle de Bravo, State of Mexico, 1971 (An assembled two-piece vertical seam mold and newly made pieces are at Señora Reyes's feet).

Figure 45. Eons of use have made the Mexican adept in the use of molds. All types are to be found—concave and convex, simple and complex—for both *corriente* and decorative wares. A preference is still held for clay, or bisque, molds, and some potters specialize in making them. Aside from the interior handle, this two-piece *olla* mushroom mold could be pre-Hispanic. Rancho Nuevo, Veracruz, 1973.

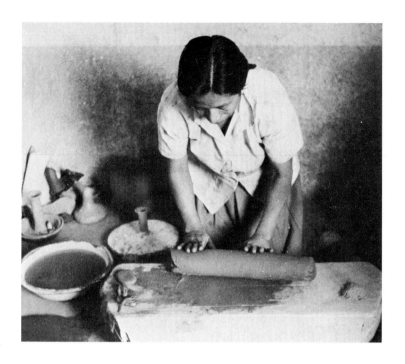

Figure 46. Regardless of the production method—modeling, wheel, or mold—clay must be "wedged," kneaded to a smooth consistency free of air pockets. Pottery of Benjamín Méndez, Tecomatepec, State of Mexico, 1972 (To the left of Señora Méndez are two mushroom molds and her batting tool.).

Figure 47. If molds are to be used, slabs of clay (*tortillas de barro*) are made ready by using the *azotador*, a batting tool devised centuries ago. The alien rolling pin is a rarity. Señora Méndez, Pottery of Benjamín Méndez, Tecomatepec, State of Mexico, 1972.

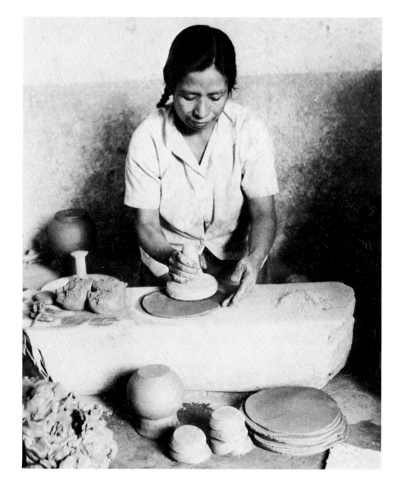

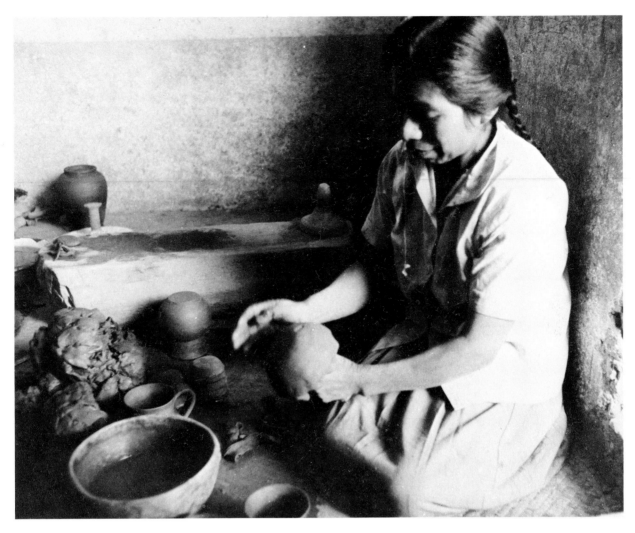

Figure 48. The clay *tortilla* is then patted and smoothed over (or into) the mold. Señora Méndez, Pottery of Benjamín Méndez, Tecompatepec, State of Mexico, 1972.

Surface Finishes: Burnishing

From prehistoric times, for both practical and aesthetic reasons, potters universally have been concerned with the surface finish of their wares. Clays suitable for making pottery are often crudely textured or of unappealing color. Simply scraping or wiping before firing leaves the fired clay surface dull, even at times badly pitted. But if it is rubbed forcefully with a hard polished tool during the final drying stages, a smooth surface will be retained

in the finished piece. Some clays burnished in this manner take on a high sheen, and even those which do not polish well may be covered with a fluid mixture of clay and other minerals. These mixtures, called slips, may be composed of clays and various coloring oxides such as iron, copper, cobalt, and manganese, and may be burnished before firing. The unglazed but highly burnished surface is still popular in Mexico, and the modern products from such places as Tonalá and Coyotepec rival, if not exceed, in beauty similar pre-Hispanic pieces.

There are regional and individual preferences for burnishing tools; in some areas, waterworn pebbles or small glass vials are used. In Tzintzuntzan, Michoacán, a few potters use the hard seeds from the *colorín* (coral) tree, and in Acatlán, Puebla, we observed one potter using the carbon core of a dry-cell battery. In the Tarascan Indian areas of Michoacán and in parts of the State of Jalisco, potters almost invariably prefer a tool of iron pyrite, and especially good ones are handed down from parent to child for generations (Figure 49). The origin of this tool is lost in antiquity. When we asked Benito Pahuamba of Huánzito, Michoacán, about his burnishing stone, he told us that as a very young boy he once questioned his grandfather about the tool and was told that it had been used in the area since "the time of the King." Our impression was that his grandfather must have referred to the last Tarascan ruler, who died at the hands of the Spaniards in 1522.

Slips

From the genesis of pottery in the New World, slips have been used as an overall surface treatment to cover the entire pot, hiding defects in the clay and making burnishing easier, as well as for painting decorative designs. Most early slips were composed of local iron-bearing minerals, hematite and fine-grained clays. Occasionally small amounts of other materials, a good white clay or an iron manganese ore for black, were imported from hundreds of kilometers away. Even so, the palette was generally restricted to whites, tans, and ochre yellows, through rust reds to dark browns and blacks. Blues and greens were rare.

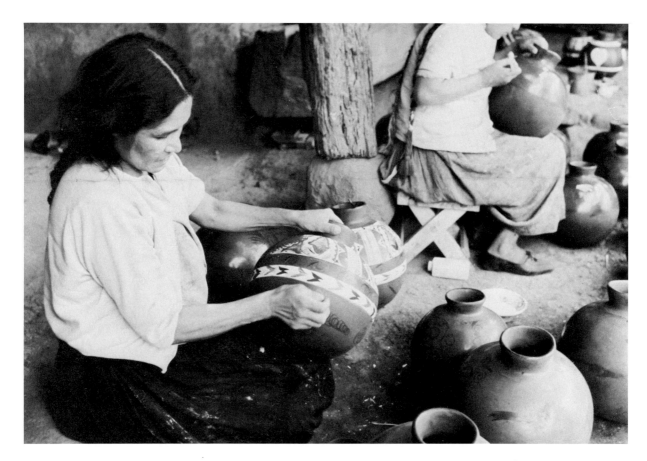

Figure 49. The hand of the past guides regional preferences in surface finishes. Some pottery families adopted simple glazes three centuries ago; others retain their Indian heritage in the use of slips and burnishing. Competence in burnishing is a source of pride, and good burnishing tools are highly prized. Pottery of Benito Pahuamba G., Huánzito, Michoacán, 1971 (Pictured above are the wife and daughter of Señor Pahuamba burnishing.).

When brilliant reds and yellows, and even blues and greens, are found on pre-Hispanic pieces, these colors are usually due to a postfiring painting. Such pieces are identified in books and museums as "stucco painted wares," and were limited to ceremonial pieces. Anthropologists speculate that many were decorated by the same artists who painted Mexico's famous temple murals. These stucco painted wares, as the name implies, were first primed with an unusually hard plaster and then painted. Many of the pigments still retain their brilliance. Unfortunately, the contemporary Mexican potter who employs this identical method often uses commercially available pigments similar to poster paints, finishing off his work with a coat of varnish. As

45

might be expected, his bright colors quickly fade, particularly when exposed to sunlight, to muted pastel and gray tones.

Glazes

Until recent times glazes have not been an important part of Mexican ceramic tradition, and while we certainly do not wish to bore our readers with technical details, some understanding of the nature of glazes is necessary to comprehend the problems facing the Mexican potter.

A glaze may be defined as an aluminum silicate glass fused to a clay surface. Both alumina and silica, singly and in combination, require extreme temperatures to melt, unless a third component called a flux is added. There are many chemical elements that will serve as fluxes. Each of them contributes different qualities to the glaze, both in the temperature at which the glaze will melt and in its final appearance. For example, the early Egyptians used sodium combined with a small amount of copper to produce their low-temperature crackled turquoise glazes. Lead, on the other hand, may be combined with copper to create a low-temperature glaze, but the result will be a grassy green and, if properly compounded, without the crackles.

Another low-temperature flux, lithium, has been discovered in recent times, but it produces an appearance quite different from either lead or sodium. Because it is a rarer element, lithium compounds are more expensive than the simple lead oxides to which Mexican potters are accustomed.

In Europe, both sodium and lead have long histories of usage as glaze fluxes, but they seem never to have been used deliberately in the New World before European arrival. Prior to the Conquest, only two types of wares could possibly be considered glazed wares—the "Rio Grande Glaze Paint Wares," on which the glaze was limited to small areas and applied in patterns in the same manner as other decorative slips, and the "Plumbate Wares," which were coated with what may be described as a vitreous slip, not a true glaze. Both of these probably resulted from accidental discoveries of deposits of slip materials which happened to include lead and other fluxes.

Considering the long heritage of ceramics in Mexico, glazes are

"johnnies-come-lately." The indigenous potter adopted glazes reluctantly and only at the insistence of the Spanish conqueror (Figures 50, 51). This reluctance can still be seen: in areas where Spanish influence was weak, the Indian potter still does not use glazes; and in areas of long and strong Spanish domination, their use is limited mainly to thin transparent washes over otherwise traditional slips. There has been little inclination to experiment, and,

Figure 50. In other places European traditions prevail. Glazes and universally known glazing techniques are commonly used. *Alfarería de J. Cruz Rodríguez Hernández,* Dolores Hidalgo, Guanajuato, 1971.

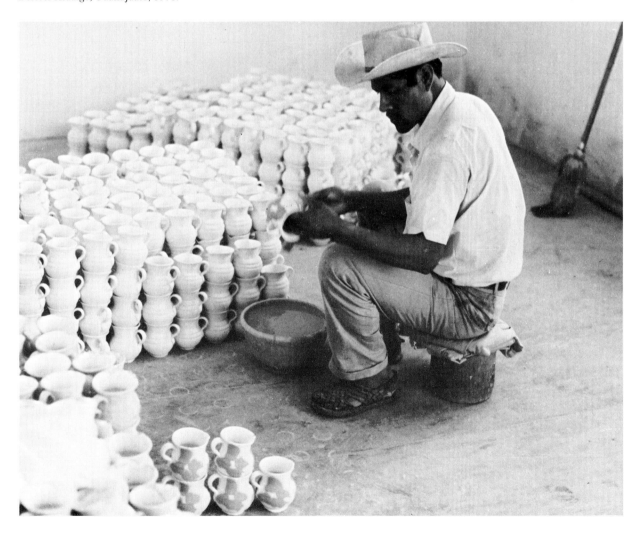

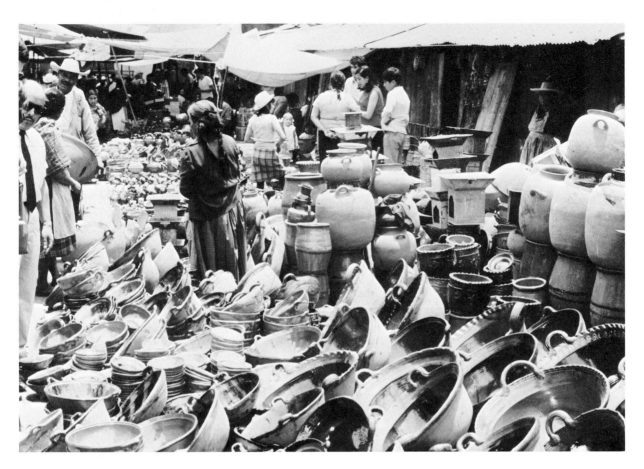

Figure 51. Most Mexican pottery, however, like the people, is *mestizo*, a mixture of two worlds, the Indian and the Spanish. Market Day, Toluca, State of Mexico, 1971.

generally, the Mexican potter's glaze methods have altered little from those introduced by the first Spanish colonists.

Because of their nostalgic remembrance of their homeland, the early Spanish immigrant potters and their heirs have also shown little interest in changing their glazes. For tablewares, their preference has always been for *majolica*, which was the vogue in all Europe during the time of the Conquest and early days of settlement. (*Majolica* is an opaque white, lead-tin glaze which may be decorated with a variety of colors.) To the Spaniards, wares used solely in the kitchen needed only a functional seal coat to prevent leaking, and, for the most part, they successfully taught the Indians to do this.

Today for his glazes the average Mexican folk potter still uses the Spanish-introduced simple mixture of litharge (generally known as *greta*) and

some aluminum silicate mineral such as the siliceous white clay called *barro blanco*. These materials he obtains in a crude form which requires hand-grinding. Otherwise he measures and mixes inexactly. Only for colored glazes, where rather precise amounts of colorants are required, does he determine the proportions by weight. Otherwise the formula is simple—so many cups of *greta* to so many of clay.

Despite the seemingly casual application by pouring (or in the case of large stewpots by brushing with a wide brush), the thickness of glaze application is carefully controlled. Frequently, pieces which must go on the kiln bottom, where the wares get hottest for the longest period of time, receive thinner coats than those near the top. The thickness of application also varies with type of ware and type of clay.

The Lead Scare

An additional point about glazes should be made: no material, including glass and glazes, is completely insoluble. Minute amounts of chemicals will be leached out of even the most carefully made high-temperature wares. The crucial questions are: how much, and with what solvents? For example, water, even when stored for a long time, will dissolve only an infinitesimal amount from a glaze, but such mild acids as dilute acetic acids (vinegar, and orange, lime, lemon, or tomato juices) may make significant inroads into the surface of the glazes.

From a technical standpoint, the glaze used by the Mexican potter is not a balanced glaze. A large part of the alumina and silica in the final glassy coating comes from the lead oxide's dissolving the surface of the clay vessel itself. The result of this is that the crucial ratio between the glaze components—lead, alumina, and silica—varies greatly from potter to potter, from kiln to kiln, and even from pot to pot. In effect, this means that while two pieces may look alike, the glaze on one may be considerably more soluble in a mild acid than the other.

Fifteen years ago, the world was scarcely aware of the health hazards of such heavy metals as lead. "Lead poisoning" was a jocular term for a bullet

wound. The recent lead scare in the United States has changed all this, and many pottery buyers shy away from any lead-glazed ware.

With this new awareness, the United States (and many other countries) hastily enacted laws controlling the use of lead in glazes and imposed import bans on any pottery which was not "certified" as having passed stringent acid-leaching tests. For an initial period, U.S. Customs officials were over-zealous, prohibiting the importation for resale of all food service utensils, both glazed and unglazed. Even unglazed toy whistles were briefly banned. This was complete nonsense. Any danger of lead poisoning that might exist lies not in the clay but in the glaze.

Although tourists to Mexico were still permitted to bring Mexican pottery back with them for their own use, the lead scare had a dramatic impact on the foreign tourist market. For the Mexican potter dependent on export or tourist purchases, it was a disaster. He was baffled and outraged, for he had no personal knowledge that his pottery had ever made anyone sick.

Unfortunately, the symptoms of lead poisoning are easily attributable to other causes, and because lead is a cumulative poison, a daily consumption of even minute amounts can eventually build up to dangerous levels. While the lead scare in the United States, like so many other such alarms, was exaggerated, there is reason to use glazed Mexican pottery with caution. If a few basic rules are followed, there should be little danger, if any, to human health.

1. Acid foods and drinks should not be stored in glazed vessels.

2. The daily use of glazed pitchers and drinking vessels for acid drinks such as orange juice, lemon or limeade, or tomato juice should be avoided.

3. Glazed cooking pots should not be used to prepare such acid foods as tomatoes, or such fruits as limes, lemons, oranges, and plums.

4. The Mexican *cazuela*, or stewpot, though an ideal shape for tossed salads, should not be used with dressings containing vinegar or lemon or lime juice; certainly, not on a regular basis.

5. Under no circumstances should *green-colored* glazed pottery be used for any drinks or moist foods. Copper, the green colorant, dramatically increases the lead release from lead glazes.

In all probability, the occasional use of Mexican glazed pottery, even for

the most acid of foods and drink, would pose no problem for the average user, though in a few rare instances it might. The crucial question is how much lead a person may already be ingesting from other sources. For example, some old buildings painted with lead paints have begun to deteriorate, dusting and flaking off almost pure lead oxide from their walls and ceilings. These lead oxides are ingested by breathing. A few very old structures still have lead water pipes which are slowly releasing lead into the drinking water. Even some printing inks used in newspapers and periodicals contain lead, which may be ingested from the hands. Possibly the most dangerous source of all is from children's spitballs made from these publications.

At first the official Mexican position concerning the hazards of lead poisoning tended to agree with that of the Mexican potter, ridiculing the import restrictions. But as the evidence piled up, the government came to recognize that lead glazes might present hazards. Consequently, both private and public attempts have been made to find a substitute for lead.

For a variety of reasons, most of these efforts have failed. The potter, knowing that high gloss transparent glazes sell well, insists that any new glaze he employs be like the old in appearance. He further insists upon the same methods of mixing, applying, and firing his glazes. And, finally, he objects to paying more for the new materials than for the old. The technical problem of finding a substitute glaze is relatively simple, but few solutions satisfy all these conditions.

3

The Everyday Pottery of Mexico: *La Loza Corriente*

For centuries *la loza corriente*, the common, everyday utilitarian pottery of Mexico, has played an important role in almost every facet of Mexican life, and the roots of its many forms lie deep in the origins of Mexican culture (Figures 52–53). Some shapes are unique, found nowhere else in the world. Others are natural ceramic forms. Their configurations are inherent in the nature of their use and the medium from which they are made, clay. Similar forms reoccur in many times and places throughout the world.

Usually, little time is spent in decorating *corriente*. But this depends upon the specific use of the piece, the customs of the region, and the momentary inclination of the potter (Figures 54–55). There would be little point in decorating the outside of an *olla* (cooking pot) which will soon become soot-blackened from wood fires. On the other hand, the colander used for washing the lime-soaked corn for tortillas (known as a *pichancha* in some areas) might have a few painted flowers or birds, simply because the painting of them brightened the potter's day. Decoration of *corriente* ware, however, does not increase the value or the price, for the buyer is more concerned with use than appearance.

In the highrise apartments of Mexico City, Monterrey, and Guadalajara, stainless steel pots with copperclad bottoms rest on electric stoves, but almost invariably tucked away on an upper shelf of the kitchen cupboard are a few pieces of *corriente*. In rural Mexico, however, the traditional kitchen with its

Figure 52. From Aztecan times to the present, weekly village markets have maintained a section devoted to *corriente* ware. By early dawn on market day potters arrive by foot, burro, third-class bus, and truck. But the ancient tumpline backpack is becoming increasingly rare. Museum display, *Museo de Arte Popular*, Toluca, State of Mexico, 1971.

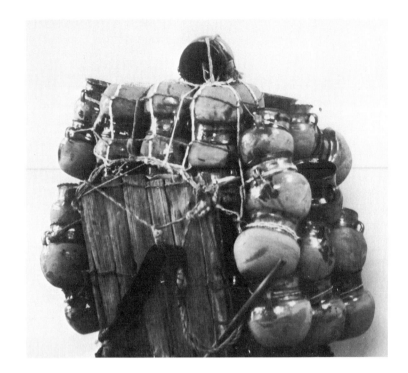

Figure 53. By the sides of isolated roads and bustling highways bales of pots waiting to be loaded atop a third-class bus are a common sight. Tzintzuntzan, Michoacán, 1971.

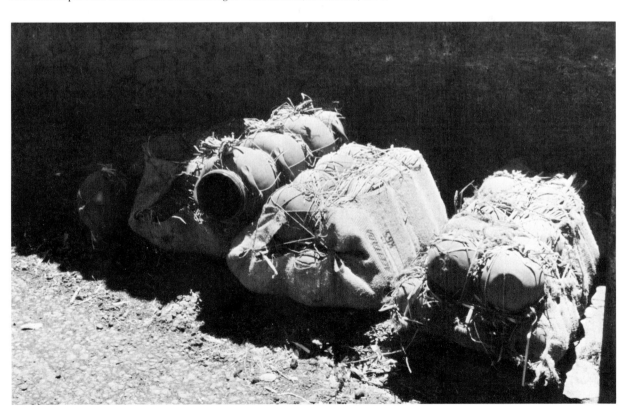

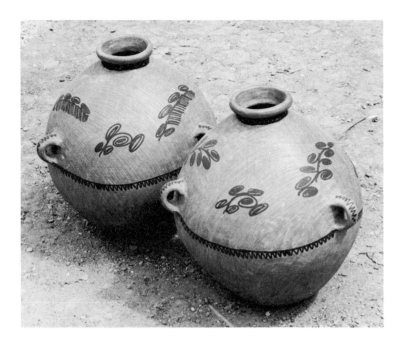

Figure 54. A bulbous form, lightly burnished and with a touch of slip decoration, characterizes the style of southern Chiapas. Amatenango del Valle, Chiapas, 1973.

Figure 55. The decoration of this *cántaro* from Oaxaca's wild Pacific coast seems strongly African in feel and is totally different in decoration from other *ollas*. Oaxaca, Oaxaca, 1973 (Photographed in the folk arts shop of Señora Lourdes Audiffred B.).

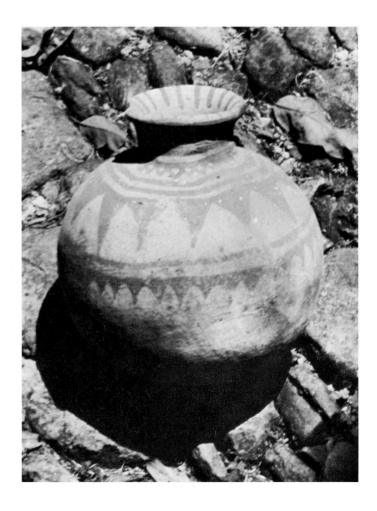

traditional clay pots remains the rule. The stove, if there is one, is a raised hearth of adobe or soft-fired brick, and if the family is somewhat prosperous the hearth's exterior may be covered with decorative glazed tiles. At least one wood or charcoal burner will be topped with a *comal*, the griddle for cooking tortillas. These old-time inexpensive clay griddles are fragile and rarely last more than a few months, so many housewives now use a sheet of metal for this purpose.

Changes in the Mexican diet were inevitable with the coming of the Spaniards. In 1519 Hernán Cortés introduced wheat to Mexico. Over the years the popularity of wheat breads has increased, and the Mexican *bolillo* is one of the finest hard rolls made anywhere. But corn, mainly consumed as tortillas, remains the Mexican staple. In villages and small towns tortilla factories with mechanized equipment are taking over the home chore of grinding the corn and turning out the tortillas. Nevertheless, no young bride could properly set up housekeeping without her own stone metate to grind the corn, and her own *comal*, of either clay or metal (Figures 56, 57).

The clay *comal* and the stone metate are the only kitchen utensils which the alien eye might find strange; they are peculiar to certain corn-growing areas of the New World. Other kitchen ware would not appear unusual, although the customary use of some Mexican clay pots could be easily misunderstood, mainly because many clay vessels are placed directly over an open flame. A regular pot of the Mexican kitchen, for example, is the lidless *cazuela*, or stewpot (Figure 58). (*Cazuela* is often mistakenly translated as "casserole," but this is incorrect since a casserole as a rule is a covered baking dish.) *Cazuelas* are two-handled and range in size from a liter or two up to mammoth ones of a hundred liters (Figures 59, 60). To the foreigner, these giant stewpots resemble great salad bowls for large parties. A similar form, the *cazo*, is used for cooking sweet dishes, although in some sections housewives insist that sweets can only be properly prepared in copper *cazos*; some are adamant that *cazos* are never made of clay.

Another basic kitchen pot is the *olla* (literally, pot) which comes in a wide variety of proportions and sizes. Some *ollas* have handles, others do not (Figure 61). Many natively Mexican dishes are prepared in them, including frijoles. Virtually the same form, but with a single handle, serves as a mug or

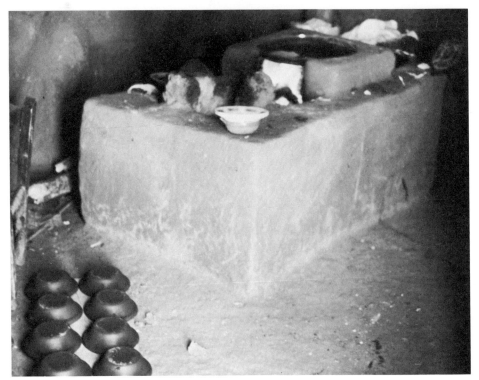

56.

57.

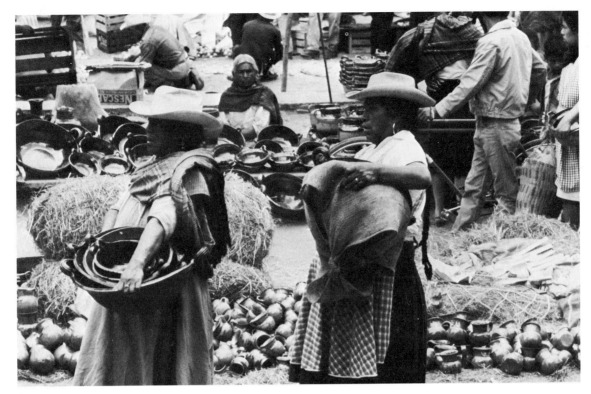

58.

Figure 56. Even indoors, cooking may be done on the earthen floor, but more prosperous families have raised hearths. In this Tarascan kitchen a fire blazes under a clay *comal* on which a tortilla cooks. Newly molded bowls sit drying on the floor. Capula, Michoacán, 1971 (Photographed in the home of the Ramón Espinoza family.).

Figure 57. In country and village kitchens smoke is free to find its way out through thatch or tile roofs. Barely visible against the sooty wall hangs a *comal* ready for use, and beside the fire pit sits a *metate*. Other *corriente* cooking and serving dishes, along with twentieth-century products of glass, metal, plastic, and porcelain, line the walls in a curious blend of antiquity and modernity. Tonalá, Jalisco, 1973 (Photographed in the home of the Juan Frías family.).

Figure 58. Astute buyers reach the market early. One woman leaves with *cazuelas* of varied sizes, while a second carries a single large *olla* wrapped in a burlap sack. By midday, the potter may be willing to make a deal with a *comerciante*, or trader, for all his unsold pots. Many *ollas* wind up in other village markets or city shops. Metepec, State of Mexico, 1971.

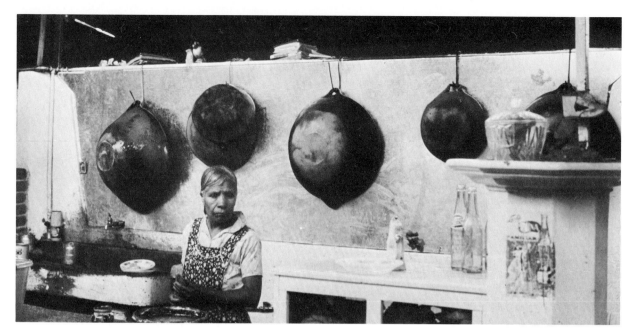

59.

60.

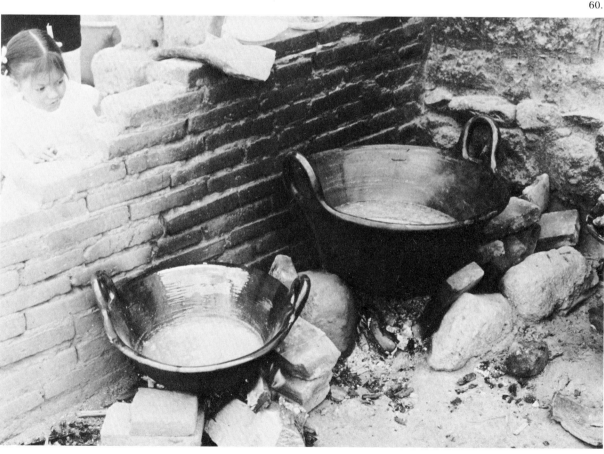

61.

Figure 59. One of the basic cooking vessels is the *cazuela*. While little by little metal pots and pans are displacing them, clay *cazuelas* are still widely used in food stalls, restaurants, and many homes. Toluca, State of Mexico, 1971.

Figure 60. In farm villages some cooking may be done outdoors. On this day rice bubbles in the larger *cazuela* and a soup simmers in the smaller. A third *cazuela* (not shown in the photograph) holds a pile of already cooked chicken, to be added later to the rice. La Trinidad Tenexyecac, Tlaxcala, 1973.

Figure 61. Another basic utility pot, the *olla* may come with or without handles in a wide variety of proportions. Smaller single-handled modifications of this form serve as cups (*tazas*) and pitchers (*jarros*). Larger, sometimes mammoth versions are used as storage jars, primarily for water. Oaxaca, Oaxaca, 1973 (This pottery is made in nearby Santa María Atzompa and brought to the state capital for sale.).

a pitcher, or as a chocolate cup. While these shapes are pre-Hispanic in origin, as are many of the foods cooked in them, they are similar to pottery forms found throughout the world.

In the remote mountainous areas of the State of Oaxaca a unique pre-Conquest variation on the *olla* is still made. Known in the Mixe area as a *patojo*, or shoe (Figure 62), its asymmetrical shape was designed so that the toe of the shoe could be shoved into the fire burning under the *comal*. Thus, both tortillas and frijoles could be cooked at the same time with a single small fire. (Some anthropologists have suggested that the Mixe Indians may have used the shoe as a burial urn for the human placenta, since *patojos* have been found buried in the floors of ancient houses. Their dusty contents and the manner in which the urns were sealed give credence to this theory.)

A variety of bowl forms (*platos* or *cajetes*) and tub shapes (*tinas* or *apaxtles*) varying in size from small condiment dishes to tubs large enough to bathe in, are also standard kitchen equipment in affluent village homes (Figure 63). To the foreign eye, only one of these might appear strange; it has a tripod base and the interior is roughly textured, often with decorative, deeply incised grooves. Called a *molcajete* (a contraction of *moler*, to grind, and *cajete*), it is used to crush chili peppers or small seeds and herbs in the preparation of hot spicy sauces (Figure 64). The *molcajete* is indigenous to Mexico and usually made of volcanic stone. In those areas where the stone is not available clay is used.

The pre-Columbian colander in many cases is no longer used for the purpose for which it was originally designed. Most of today's *pichanchas* are bought by city dwellers to use as hanging planters or lampshades. As late as the nineteenth century, clay colanders were common in Europe and the United States, but lighter and more durable metal strainers have long since replaced them. This is happening in Mexico, and, gradually, as cheap plastic and metal become available, the clay product is falling into disuse (Figure 65).

The *olla*-shaped *tinaja* and the barrel-shaped *barril*, both designed as water storage jars, will also die out. As villages receive piped water, these jars become obsolete (Figures 66, 67, 68). But like rural people everywhere, Mexican villagers are conservative and suspicious of the untried. Water piped into the home means an outlay of money for which they are frequently ill

Figure 62. An ancient asymmetrical *olla* form unique to Mexico is symbolic of *la loza corriente*. Known as the *patojo* (shoe) it is made so that the toe may be shoved under a *comal*, or griddle, thereby cooking frijoles and tortillas with a single small flame. It is a prime example of a utility pot designed to meet a specific need. *Corriente* is the pottery of the people. Many of its forms may be found in other pottery areas throughout the world, and some, having met the test of generations of use, are classic. Nochixtlán, Oaxaca, 1973.

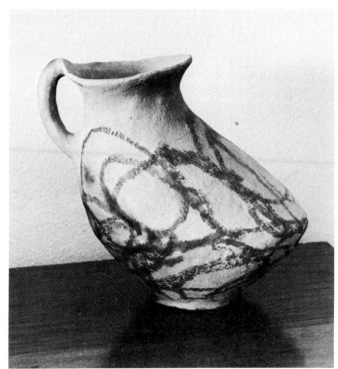

Figure 63. A variety of bowl and tub shapes ranging from small condiment dishes to tubs large enough to bathe in may also be found in affluent rural households. Oaxaca, Oaxaca, 1971.

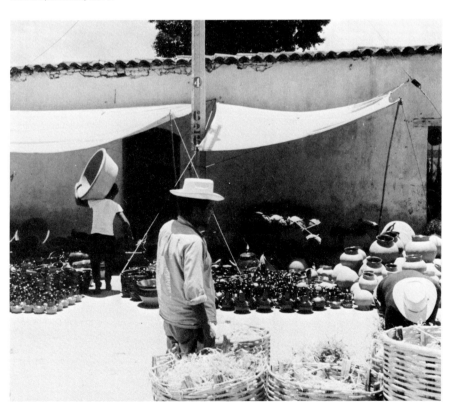

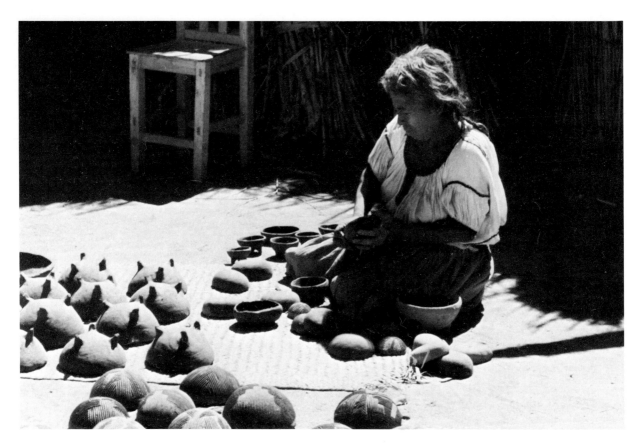

Figure 64. Still an essential implement in Mexican kitchens, the *molcajete* for grinding peppers and herbs is usually carved from volcanic stone. But in regions lacking suitable stone, clay substitutes are made.

Deep striations in the bisque molds (foreground) suitably texture the interior of the finished grinding bowls which are drying on the straw mat. Like their stone counterparts, clay *molcajetes* have tripod bases to provide stability. San Francisco Altepexi, Puebla, 1973.

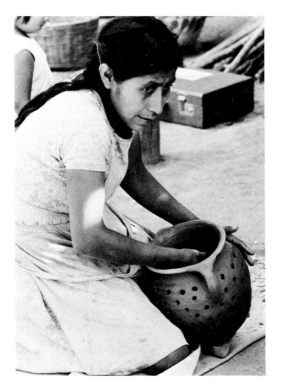

Figure 65. The clay colander (sometimes known as a *pichancha*) is being rapidly replaced by plastic and metal, even in rural kitchens. Most *pichanchas* are now sold to city dwellers as hanging planters. Zumpango del Río, Guerrero, 1972 (Pictured is the wife of Señor Francisco Pastor.).

Figure 66. Year after year, as water is piped into more and more villages, the production of large storage jars, the *cántaros* and *tinajas*, declines. This *tinaja* may well end up as a planter in some elegant Mexico City garden. *Alfarería Gerónimo Alonso, Barrio de la Luz*, Puebla, Puebla, 1971.

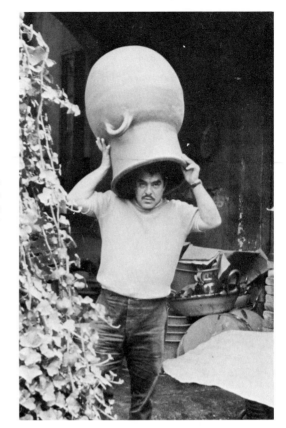

Figure 67. Or perhaps in some border tourist shop. (After hasty roadside repairs, the truckers reload for the long journey from San Ildefonso, Querétaro, to Laredo, Texas.) On the highway outside the city of Querétaro, Querétaro, 1971.

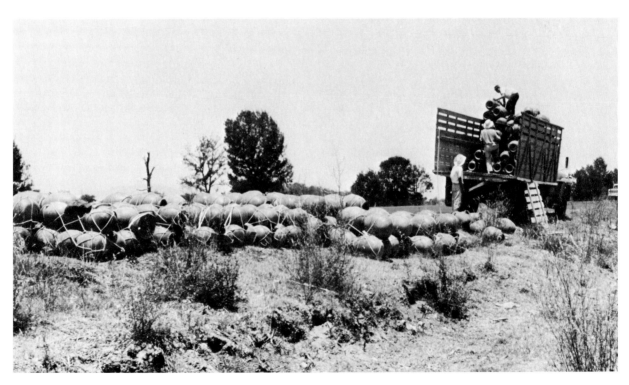

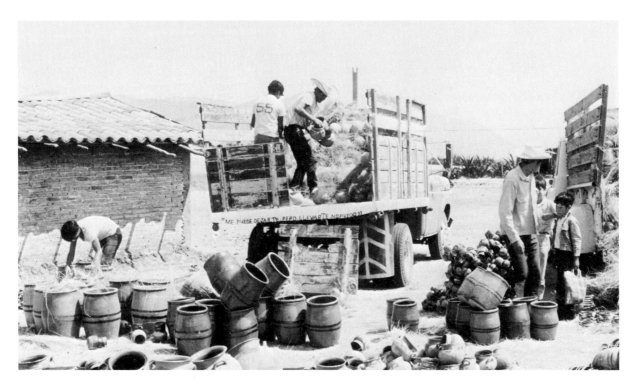

Figure 68. In recent times, many potters have formed marketing cooperatives, sometimes buying or hiring trucks to transport their wares. Temascalcingo, State of Mexico, 1971.

prepared. As a result, even where piped water has been made accessible, many people with long memories of thirsty days still prefer to rely on the traditional clay jars to store their water and to keep it cool.

Both the *barril* and the *tinaja*, while primarily associated with water storage, have served other uses: for hundreds of years such things as grains and pulque, the potent wine of the maguey plant, have been stored in them, and giant *tinajas* are still sometimes half-buried in the earth for use as ovens.

Huge pre-Hispanic pottery jars are displayed in Mexico's major museums, but anthropologists and archaeologists are not always certain how they were used. In one Oaxaca museum there are large vessels which are almost identical with certain *tinaja* forms still made in Spain. The Mexican examples are definitely pre-Hispanic, and museum authorities have identified them as ancient Indian burial jars. It seems more likely to us, however, that then, as now, these jars served a multitude of uses, and that it is pure coincidence that their size and shape made them suitable for the interment of human bones.

Plate 1. As the kiln reaches peak temperature the upper layer of pots begins to glow faintly with the color of black cherries or oxblood, and at this point there is often an accumulation of soot on the covering shards. Zinapécuaro, Michoacán, 1973.

Plate 2. Generally *cántaros* are large, but some are no more than oversized canteens and are often used by farmers working in the fields. San Miguel Aguazuela, Veracruz, 1973.

Plate 3. Early colonists in Puebla imported skilled potters from the homeland. Today, although Puebla's *majolica* pottery and tiles are clearly Spanish in origin, they are distinctly Mexican in feel. (Here, in the Talavera plant of Señor Isauro Uriarte B., the kiln master interrupts his duties of firing the large bottle kiln behind him to heat a pot of honey to be used as a glaze binder.) Puebla, Puebla, 1971.

Plate 4. Over almost five centuries Puebla's Talavera plants have poured out millions of tiles. They cover floors, walls, and roofs of public and private buildings throughout all Mexico. Dome of the Church of San Cristóbal, Puebla, Puebla, 1971.

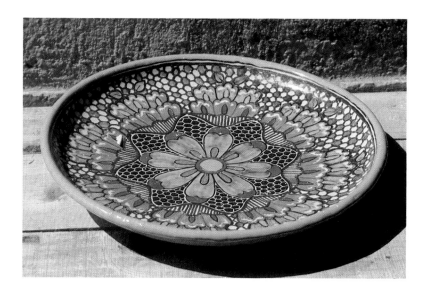

Plate 5. While Talavera production has dwindled in this century, a few shops still make high quality wares. Large plate from *La Trinidad*, the shop of Señoritas Margarita and Concepción Guevara, Puebla, Puebla, 1973.

Plates 6 and 7. Unlike most pottery towns, Izúcar de Matamoros produces no *corriente*. Nevertheless, the exuberant works of two extended families have achieved international recognition for their verve and totally Mexican charm. The most familiar of these works are the endless variations of free-standing candelabra. (Unless the buyer insists to the contrary, all pieces are stucco-painted.) Candelabra from the shop of *Heriberto Castillo y Hermanos*, Izúcar de Matamoros, Puebla, 1971.

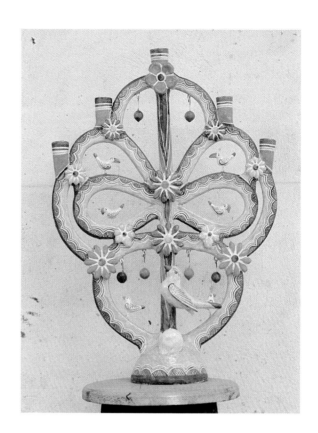

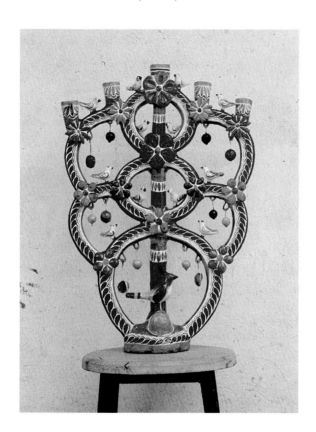

Plate 8. Now purely decorative, these modern pieces had their origin in simple ceremonial objects made for religious festivals. Hanging candelabra from the shop of *Heriberto Castillo y Hermanos*, Izúcar de Matamoros, Puebla, 1971.

Plate 9. Some of Acatlán's more expansive potters have replaced the once sedate ceremonial candelabra with whimsy and gaiety. Candelabra from the shop of Alfonso López M., Acatlán, Puebla, 1971.

Plate 10. The pottery from the Valley of Oaxaca is a paradox. Much of its decorated wares is *corriente* and much of the *corriente* outstandingly beautiful. Within the city of Oaxaca one shop has adapted decorative motifs from the nearby archaeological sites —but not the pottery—of Monte Albán and Mitla. Sugar bowls in the Monte Albán style from the *Alfarería Jiménez*, Oaxaca, Oaxaca, 1971.

Plate 11. One traditional form from neighboring Atzompa, the *chivo de chía*, deserves special note. Initially devised to be planted with delicate fleece of lime leaf sage (*chía*) and used as springtime votive offerings, the *chivos* are now made as ornamental figures varying from the original small size to several feet in height. This particular one stands about thirty centimeters high. A few Atzompa potters also specialize in clay toys and small figures. (See the chapter on artists for a discussion of the unique work of Teodora Blanco.). Photographed at *Casa Yalalag*, the folk art shop of Enrique de la Lanza, Oaxaca, Oaxaca, 1971.

Plate 12. While suggestive of timeless precursors, the decorative style of Guerrero's pottery from the Balsas-Mexcala region has developed recently into a Ping-Pong match between the bark-paper painters and the potters. The game started when the painters picked up the simple flora-fauna motifs of local pottery and expanded upon them by using brilliant colors. The potters responded by decorating with more finesse, but still with their traditional mineral colors. Ameyaltepec, Guerrero, 1973 (Bark-paper painting from the authors' collection.).

Plate 13. Most Metepec functional wares (even when decorated) are still *corriente*, but the zoomorphic *botellones* for pulque are frequently painstakingly ornamented. Photographed in the *Museo de Arte Popular*, Toluca, State of Mexico, 1971.

Plate 14. Wondrously intricate candelabra and trees-of-life depicting biblical themes are Metepec's best known decorative wares. While moderate-sized pieces such as this are most popular, larger "trees" are common, and one extraordinary potter (who is discussed in the chapter on artists) creates "trees" up to two meters, forty centimeters in height. Photographed in the *Posada de la Basílica*, Pátzccuaro, Michoacán, 1971.

Plate 15. Traditionalists may censure the pottery of Dolores Hidalgo as "decadent Talavera" or "imitation *majolica*." But we found skillful throwing, vigorous brushwork, and a spirit of technical innovation pervading the town. Vase by Felipe Vásquez Gutíerrez, Dolores Hidalgo, Guanajuato, 1971.

Plate 16. Many potters in Dolores are attempting to improve their production methods and at the same time retain the Mexican feel of their pottery and tiles. *Taller de Gonzalo Bárcenas Fajardo*, Dolores Hidalgo, Guanajuato, 1971.

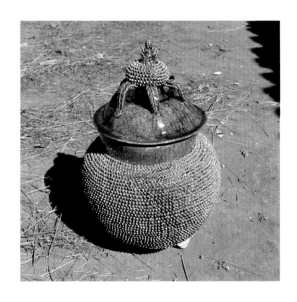

Plate 17. In the Tarascan sierra of Michoacán, both Patamban and San José de Gracia make the famous pineapple forms. Early *piñas* were green glazed jars covered with thornlike and often crudely applied daubs of clay, and topped with stylized leafy covers. Gradually the daubs were refined and put on in controlled patterns. San José de Gracia, Michoacán, 1973 (The pineapple is the work of Bartolo Gutiérrez.).

Plate 18. In a third tiny sierra village a handful of families create weird supernatural figures, grotesque monsters which evoke the horrors of some Dantesque hell. While Ocumicho has a history of making clay toys and figurines, the present style is of recent origin. (The best of this work is discussed in the chapter on artists.) Ocumicho, Michoacán, 1971.

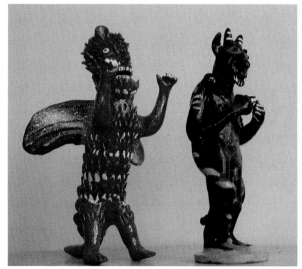

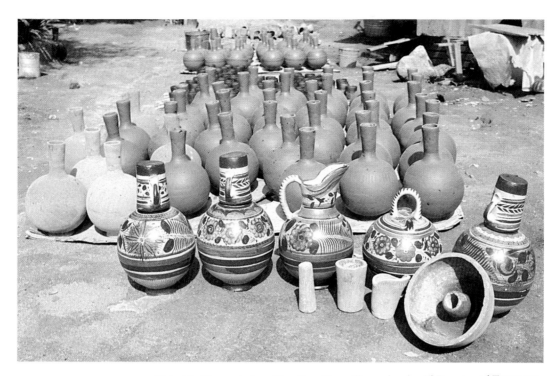

Plate 19. The works from Tonalá and two villages close by, El Rosario and Tatepozco, epitomize Mexican decorative ceramics. El Rosario's production is limited to a variety of *botellones*, usually cinnamon colored and made mainly from one type of mold, slip decorated with bands and floral patterns, and then burnished. For tourists these unglazed water bottles and pitchers prove ideal souvenirs, and *botellones* from El Rosario grace the homes of many Mexicans who find them useful as well as ornamental. El Rosario, Jalisco, 1971 (Photographed in the patio-pottery of José García.).

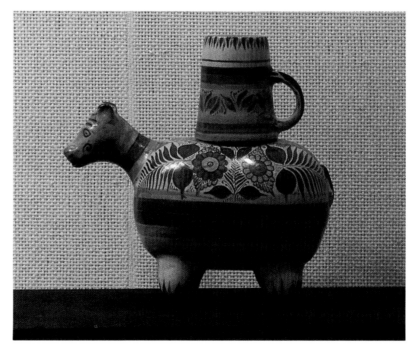

Plate 20. Tatepozco *botellones* are similar to those from El Rosario but sometimes come in zoomorphic shapes. San José Tatepozco, Jalisco, 1973. (Approximately 30 cm high, the *botellón* is by J. Guadalupe Fajardo.).

Jars for the portage of water and other liquids vary greatly in size and form according to regional customs, the distance to be carried, and the mode of transportation (Plate 2). Women carry relatively small round water *cántaros* on the shoulders or head from the nearest streams, ponds, or village fountains. *Cántaros* designed to be carried in this manner are handleless. For longer distances, larger jars are backpacked by the ancient tumpline or, if the family can afford it, four of these jars are strapped to the sides of a burro (Figures 69–70). Most larger jars have loop handles through which a rope may be passed for ease in carrying (Figure 71). Although there are regional differences in Mexican *cántaros*, some of which can be traced back hundreds of years, these forms are eminently practical and would be recognized immediately for what they are in Africa, Spain, the Middle East, or other arid regions of the world.

Generally, there are slight differences in shape between jars for carrying potable water and those for such other liquids as salt water or the Mexican alcoholic beverages pulque and aguardiente. The lovely salt-water jars from the Acatlán area in the State of Puebla, for example, are generally taller and narrower, characteristics which assist in the drying of the salt by exposing a greater surface of the porous clay to evaporation. Jars for alcoholic beverages are more globular, and their surfaces may be sealed to reduce or to prevent evaporation (Figure 72). There is, of course, always the possibility that the vendor demands a distinctively shaped vessel as a trademark of his wares.

Water bottles to keep small amounts of drinking water readily available in the home, and dinnerware, such as plates, platters, fruit and soup bowls, are usually more highly decorated, and consequently are considered "fine pottery," even though they may be crudely made. These items are discussed in the section on ornamental and decorative pottery.

The distinction between what is *corriente*, and what is not, is sometimes difficult, and the classification of certain pieces depends largely on the classifier. Rural potters have strong opinions, based on their experience as to what is suitable for sale in large cities and what is bought by villagers. Often their judgment is also based on the amount of work, the time spent in making or decorating the piece, and whether it is unglazed, partially glazed, or completely glazed. To them, completely glazed wares are luxury items. City

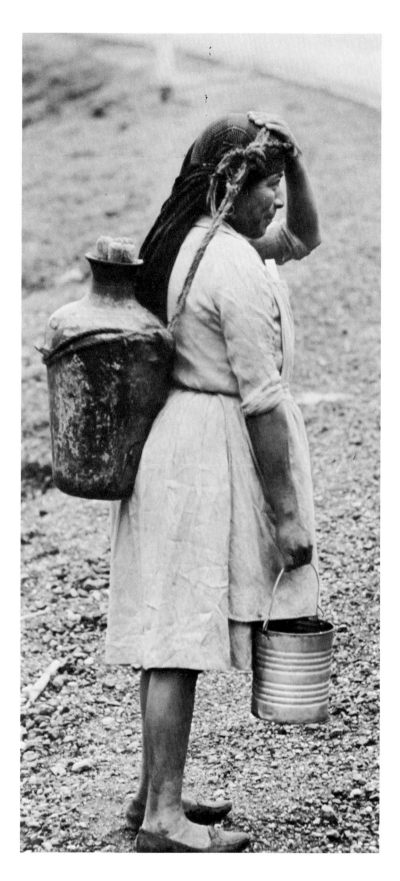

Figure 69. In Mexico's great arid regions water must be carried many kilometers, often in a single large *cántaro* by the ancient tumpline backpack. On the Pan American Highway, fifteen km south of Huajuapan de León, Puebla, 1971.

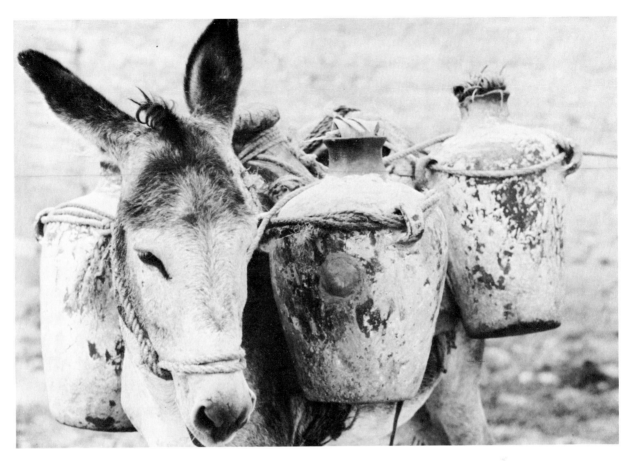

Figure 70. Or, if the family can afford it, in four *cántaros* by burro. Through repeated usage the soft porous clay is gradually sealed by minerals in the water. Chila, Puebla, 1971.

Figure 71. The design of *cántaros* has evolved over centuries. The result of generations of use, each shape conforms to the practical needs and aesthetic taste of the people of the region. Pine pitch has been freely splashed on this graceful round-bottomed jar from Nochixtlán, and a wicker ring holds the vessel upright. Nochixtlán, Oaxaca, 1973.

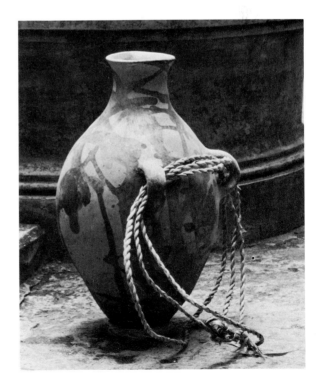

Figure 72. A pulque vendor, with her distinctively shaped *cántaros*, makes her way to the weekly market. Morelia, Michoacán, 1973.

dwellers, however, may apply different criteria and regard anything that is relatively inexpensive and commonplace as *corriente*, even though it may be highly decorated and more beautiful than the machine-made products which adorn their homes and patios.

The aesthetic quality of Mexican *corriente* ware lies in its conformance rather than in uniqueness, which is the contemporary standard of art. These are forms refined over generations to perform their specific functions well. Because they are made according to long established principles, they are truly classic. Even in decoration, individual creativity is minimal, both in motifs and in their arrangement. While some latitude is allowed in decorating, it is generally confined to local or regional styles. Personal reputations are built through superior workmanship and, occasionally, through achieving stylistic subtleties which the community as a whole recognizes.

Part of an outsider's aesthetic response to a clay vessel lies in the spirit and vitality which the potter has breathed into it. Clay is a versatile material. Almost any form the potter desires may be shaped from it if he uses the right technique, but each technique has its limitations. Although many different methods are used in Mexico, most potters learn only one. Despite these restrictions, or perhaps because of them, many Mexican potters develop fantastic skills, pushing their technique and their medium to the utmost.

Great pleasure may be had from seeing a job well done, whether it is a human performance or that of an implement. The *comal*, the simplest and humblest of forms, is little more than a slightly depressed disc of clay. Yet for the experienced foreign potter who has never seen one, a *comal* seventy-three centimeters in diameter sitting atop a blazing fire is an astonishing sight. For the tourist who has never worked with clay it may be only a curiosity, and for the Mexican who is so accustomed to it, mundane and unworthy of note. The foreign potter can only react with admiration. These giant circles of clay are austere and often crude, but they possess an ascetic beauty.

Among the finest of Mexican cooking wares are the huge *cazuelas* from Metepec in the State of Mexico and from La Trinidad Tenexyecac in Tlaxcala. Though at times their interiors may display a few decorative splashes of color, these are basically humble pots. For the two of us, if truth is beauty and honesty is character, then these generous and sturdy pots will prove enduring friends.

Because of their purity of form, the most universally admired *corriente* forms are those associated with water, the *tinajas* and the *cántaros*. Their shapes are free of any deception, and every element contributes to their basic function. Each curve is intellectually conceived, but is based upon the potter's intuitive sense of sound engineering construction and the use of his pot as a container.

The severely chaste black *cántaros* of Coyotepec are among the most beautiful utilitarian wares made in any place or at any time (Figure 73). They have the balanced formality of Grecian urns, but at the same time, Coyotepec pottery lacks the astringent rigidity which forced the ancient Greek artisans to relieve the severity of their vessels by decoration. Although the Coyotepec potter has begun to decorate his *cántaros*, the perforated orna-

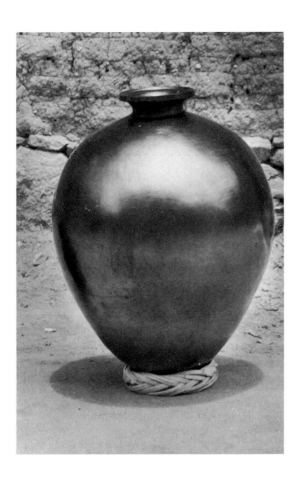

Figure 73. It is in pots for the transportation and storage of liquids that Mexicans historically have shown their greatest talent for pure ceramic forms. Coyotepec's lovely but severely chaste black *cántaros* are truly classic. Coyotepec, Oaxaca, 1971 (The work of Señora Juana Domínguez, the *cántaro* measures 70 cm in height.).

Figure 74. Just a few kilometers south of the state capital of Oaxaca, Coyotepec has responded to a changing market by converting its old but beautiful *corriente* into such things as lamp bases and vases for dried flower arrangements. Coyotepec, Oaxaca, 1971.

mentations he uses scarcely disturb the classic beauty of the basic forms (Figures 74, 75). While the decoration does not always enhance a particular piece, it never detracts from it. The form's inherent aesthetic strength inevitably dominates, even in the most elaborately decorated pieces.

The salt *cántaros* of Acatlán in the State of Puebla, while entirely different in concept from those of Coyotepec, also possess a natural beauty (Figure 76). Their appearance is rugged, and just as wrinkles reflect the character and strength of certain old people, so the accidental smoke and flame blemishes—the firemarks—increase the visual quality of these vessels.

Figure 75. And by developing new forms specifically for use as lampshades. Coyotepec, Oaxaca, 1971.

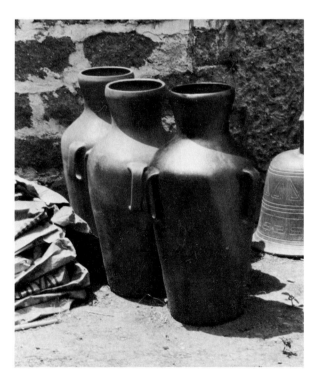

Figure 76. In arid southern Puebla a special form known as a *cántaro salinero* is made. Salt water from a deep well many kilometers away is transported in these vessels. The water is allowed to evaporate in the blazing sun, and the remaining salt is then used for household purposes. Acatlán, Puebla, 1971.

4

The Decorative Pottery of Mexico:
Ten Major Pottery Centers

The types of wares we classify as decorative or ornamental run the gamut of Mexican ceramics, from the open-fired fantasy figures of Guerrero to the Spanish style *majolica* of Puebla, and from giant storage jars and soaring trees-of-life to toys and miniatures which delight the sophisticated adult. By Mexican standards, some of the pottery included here is *corriente*, but by ours it is so inherently beautiful that it must be considered ornamental. Other works which the Mexican potter might well label *loza fina*, or fine pottery, or luxury items, we have chosen to ignore as being without aesthetic merit. We have considered a number of factors, but in the end our prime criterion has been aesthetic value (Figures 77, 78).

The ancient traditions of craftsmanship are still alive in Mexico, and the potter who makes elaborately decorated pieces refers to his work as his "labor" or his "office" in life. Being considered an artist is foreign to his very nature; he thinks of himself as an artisan (Figures 79, 80). For the most part, such potters are anonymous, although a few may develop personal or family reputations for outstanding work in a particular style. Though their pottery may lack the distinctive innovation of the individual creative artist, they follow time-honored craft traditions.

There is a natural tendency to judge present-day decorative and ornamental pottery by historical examples and to find the modern pieces wanting. This is unfair. The ancient pieces illustrating art history books, and those

Figure 77. Our list of ten centers of ornamental or decorative wares is not all-inclusive. The *tinajeras* from the Isthmus of Tehuantepec, for example, are worthy of note for their aesthetic merit but are limited in both quantity and form. The *tinajera* is a three-piece water cooler consisting of a stand (usually representing a woman), a flaring fluted bowl filled with damp sand, and a small *tinaja*, or jar, for storing drinking water. Tehuantepec, Oaxaca, 1973.

Figure 78. Aside from an occasional floral motif, in both form and decoration the jar on top is reminiscent of certain pre-Hispanic pieces. Tehuantepec, Oaxaca, 1973.

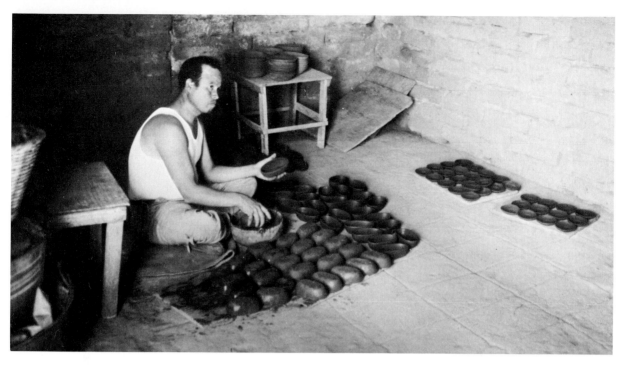

Figure 79. *Corriente* is humble pottery made by humble people. Juan Frías was puzzled by our interest in his work; he thought we should talk to potters who make *loza fina*. People such as Señor Frías consider pottery making their "destiny"; it is the only alternative to starvation. Tonalá, Jalisco, 1971.

displayed in museums, are highly selective, drawn from the work of many thousands of potters over thirty centuries. If today's ornamental ceramics lack the breadth and scope of the historical examples which have come down to us, it must be remembered that production during any given decade over the millennia undoubtedly suffered the same lack. If today we are equally selective, then a handful of isolated modern items would compare favorably with the finest of pre-Columbian wares.

As in Mexico's pre-Hispanic past, certain contemporary pottery centers have become noted for the quality of their production, particularly those places that make decorative wares. The geographical locations where they may be found are spread countrywide. Our list of ten centers is certainly not all-inclusive. We have based our choices not only on aesthetic quality but also on numbers of potters and quantity of production, variety of styles and forms, and the general atmosphere of creativity and desire for improvement. The following areas are, then, in our eyes, Mexico's most outstanding centers of ornamental pottery.

74

Figure 80. The children learn the family trade early, imitating their elders with clay-play. But unlike the older generation who see no way out for themselves, the children dream of a better life in a different world. Tehuitzingo, Puebla, 1971.

Puebla (Puebla)

The verdant coastal slopes rise gently from the sea at Veracruz for a hundred miles until they meet a magnificent but brutal escarpment soaring thousands of feet to a barren high plateau. The plateau leads to the mountains, which separate the fertile basins of Puebla and Mexico, and at the mountains' base, in 1531, a colonial settlement was established to serve as a tranquil oasis between the mountain pass to Tenochtitlán-Mexico City and the long trek to the Veracruz port. This is now the state capital of Puebla, known as Puebla de los Angeles or Puebla de Zaragoza.

Unlike Mexico City, which was built on an established Indian urban center, Puebla was founded in the sixteenth century as a New World Spanish

75

city for the express purpose of inducing the remaining roaming conquistadors and other unemployed adventurers to settle down. Spanish men were urged to bring their wives from Spain, or failing that, to marry Indian women. They were given town lots and permitted to own Indian slaves (despite the fact that under Spanish law these people were technically free). Every effort was made to create a city as pleasant and familiar as possible.

In addition, the town fathers imported skilled artisans from the homeland, among them, early colonial potters who came mainly from the regions of Toledo and Talavera de la Reina in Spain. Long before the century had ended, Puebla had become a jewel in the crown of New Spain and an important center in the manufacture of ceramic tile and Spanish tableware. Some two hundred years later, in another section of town, the *barrio de la luz* (the area known as "the light"), other potteries were established under Spanish colonial grants. Both the Talavera potters and those of the barrio worked in guild-system shops, carefully controlled by law and custom.

Puebla Talavera makers devoted themselves to the continuation of the original techniques, forms, decorations, and quality imported from the mother country; the barrio potters were allowed to produce and sell all types of pottery other than Talavera. These distinctions persist today, though by tradition rather than by law. Barrio potters make a variety of glazed wares, mainly molded utilitarian vessels, and such wheel-thrown ceremonial items as black candlesticks and incense burners, neither of particular note. The few remaining Talavera plants continue to make high quality decorative earthenware in the sixteenth-century Spanish style.

The style known as Talavera was greatly influenced by the *majolica* of the Italian Renaissance, although strong elements of Moorish and other Mediterranean cultures may be seen in it (Plate 3). The forms, while traditional, range from simple dinnerwares, to Ali Baba-size jars, to tiles for myriad uses. The decoration places a strong emphasis on cobalt blue, with yellow, orange, black, and occasional touches of green used in the polychrome wares over a white opaque base glaze. The favorite decorative patterns reveal an interplay of geometric and floral motifs, but once in a while, animal, bird, or human forms appear.

As in Spain, the Puebla Talavera potter has responded to changes in

tastes, and over the years his work has become somewhat "Mexicanized." The colonial Spaniard retained a nostalgic reverence for things European as he remembered them, or as he believed them to be, and consequently, Puebla Talavera, while taking on a certain Mexican flamboyance, has changed less than its Spanish counterpart.

Until recently the conservative approach of Puebla Talavera potters was their strength; now it is their weakness. For many years, by doggedly holding to their outmoded standards, they were able to maintain an imposing product superior to that of Talavera de la Reina in Spain. Despite the excellence of Puebla's present work, this tenacity has been in vain (Plates 4, 5). In 1971, seven Talavera workshops were still operating, two years later there were only five. Most of these will close when their owners die. Today the city is better known for its production of Volkswagens than for its pottery.

Talavera's decline is due to the same factors which have systematically destroyed handcrafted products in other countries as they became industrialized. The most expensive of all Mexican dinnerware, Talavera cannot possibly compete in price with mass-produced tableware from Mexico City. Talavera tiles are no economic rival for those stamped out by the thousands in the factories of Monterrey. Changes in taste have further reduced the market to a tiny group of Hispanophiles and a few collectors who, observing the handwriting on the wall, are now investing in a fast-disappearing market.

One may mourn the passing of this honored craft, but if it is to survive, Talavera potters must respond to contemporary needs by radical revision in design or technique. In any case, the pottery which has been known for centuries as Puebla Talavera probably will be lost.

Izúcar de Matamoros (Puebla)

The Spanish colonial magnetism of the city of Puebla weakens with distance, especially as one travels southward on the Pan American Highway. For the first fifty miles, the impression is distinctly that of a mixture of Spanish and Indian, but soon the land becomes progressively more arid and the people almost totally Indian. The sensation is heightened by the pottery

of the towns along the route: the candelabra of Izúcar de Matamoros, the indigenous *corriente* of Tehuitzingo, and the multiform wares of Acatlán.

Izúcar de Matamoros is a quiet agricultural town in the hot lowlands of Puebla, known mainly as the site of the junction of two major highways. Few people, even those living in Izúcar, are aware that anyone in town works with clay. It is by no means a pottery center.

Still, the ceramic production of two Izúcar families is broadly distributed throughout Mexico and the United States, primarily through better gift shops in major cities. While the two households are independent and competitive, differences in their wares are minor; both make the same types of forms and use the same techniques. Hand-modeled bisqueware is undercoated with gesso, a hard white stuccolike paint, then decorated with bright tempera colors, and finally varnished. Most pieces are further adorned with multitudes of dangles, beads, birds, fruits, and flowers of clay, all suspended by wires embedded in the clay before firing (Plates 6, 7, 8).

This polychrome style is said to have originated in nearby Huaquechula, a small village on the slopes of the volcano Popocatépetl. Like housewives in the United States who bake and decorate cookies before Christmas holidays, the women potters of Huaquechula traditionally prepared festive vessels of clay for Christmas and All Souls Day.

The original simple ceremonial objects made by the two Izúcar families for religious occasions were quickly recognized for their verve and totally Mexican charm, and a demand far exceeding the seasonal festival market ensued. These creations, while not so complex and elaborate as those of Acatlán or Metepec, are constantly being regenerated by variations on the old themes of candelabra and incense burners, and have extended into such new subjects as stacked animals, merry-go-rounds, chandeliers, and acrobats (Figure 81).

Acatlán de Osorio (Puebla)

Acatlán lies where the upper reaches of the Balsas-Mexcala depression touch the Oaxaca uplands. Life in the region is adjusted to the desert, where for much of the year the land is scorched sterile by hot dusty winds alter-

78

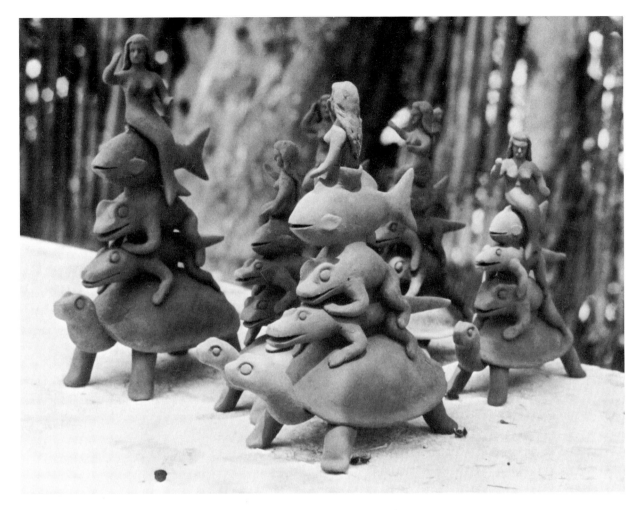

Figure 81. Two families in Izúcar de Matamoros are noted for their colorful candelabra, but they also produce such other decorative forms as incense burners, stacked animals, merry-go-rounds, acrobats, and chandeliers. Stacked marine forms (bisque state) from the shop of *Heriberto Castillo y Hermanos*, Izúcar de Matamoros, Puebla, 1971.

nating with blast-furnace oppressiveness, where seasonal gully-washers quickly drain the eroded soil, and where *tunal*, a variety of cactus, is used for firewood. Yet, for all this, an ancient pottery village persists.

There can be little doubt that Acatlán was a pre-Hispanic, and possibly important Indian center (Figures 82, 83). Even though Spanish is commonly spoken in the village, Mixtec is the language of the surrounding countryside, and Indian traditions of pottery making are strong.

While mother nature bestowed few bounties upon Acatlán, she provided

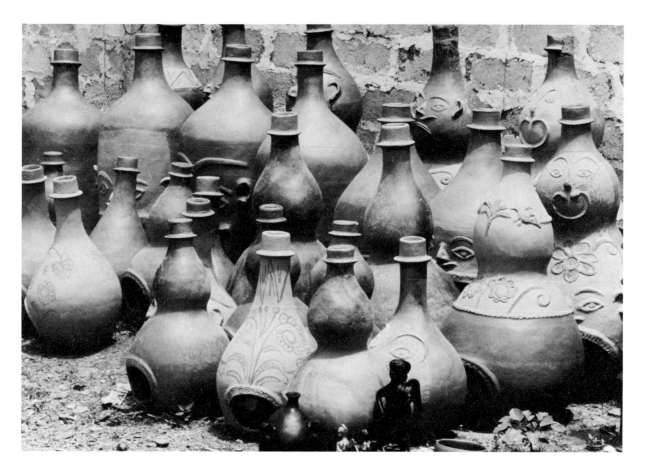

Figure 82. Acatlán produces an extensive inventory of ceramic wares with endless variations on each type of form. Here is an assortment of *chimeneas*, or fireplaces. Photographed in the patio-shop of Herón Martínez Mendoza, Acatlán, Puebla, 1971.

deposits of excellent plastic clays, as well as steatite, or *talco*, as local potters call it. This talc-clay body fires to one of the strongest and hardest earthenwares in all Mexico.

Pottery is formed both in molds and by hand-building, using a variant on the *kabal* mobile base, locally known as the *parador*. Many pieces are partially molded and partially free modeled. Burnishing is the most common finish, but much of Acatlán's new ornamental pottery is brightly decorated with paint over a gesso base coat. Other ceramic techniques, sometimes from far distant villages (such as the smudging process of Coyotepec), have been adapted to the local pottery style.

Here colonial Spanish methods have made few inroads. Glazes are rarely, if ever, used. Though firing is done in open-top kilns, the kilns fre-

80

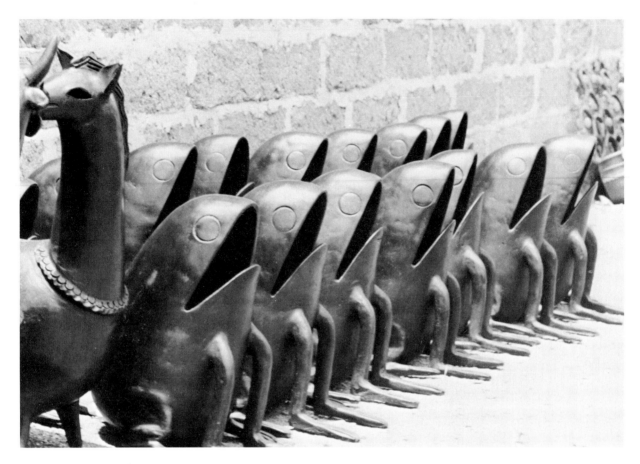

Figure 83. Small planters used for prayer images for the springtime festivals of new life have grown into large garden sculpture-planters. Acatlán, Puebla, 1971.

quently lack a firebox, and the fuel is carefully pushed in between the bottom layer of pots. Decorative styles show little trace of the Hispano-Moorish influences seen elsewhere.

Approximately one hundred potting families in Acatlán produce an extensive inventory of ceramic wares: many types of *corriente*, old ceremonial forms, and modern decorative ones. Aside from the variety and quantity of its production, the town's reputation could well rest on only two of its products, one old and the other new. The old is the lightly burnished, often beautifully fire-marked *cántaro*, aesthetically and technically one of the finest forms ever made in Mexico. The new is Acatlán's distinctive ornamental candelabra, or tree-of-life (Plate 9).

These impressive "trees" obviously evolved from smaller and less ornate

ceremonial wares. This is also true of other forms, though their origins may be more obscure. Small planters, often in zoomorphic form, have probably long been used to grow ceremonial plants, prayer images for the springtime festivals of new life. Although they are still used to adorn church altars and home shrines at Easter, their importance in insuring good crops has lessened, and the larger garden sculpture-planter no longer has any religious significance. It is possible that Acatlán's humorous portable fireplaces, too, had their origin in pre-Hispanic braziers for burning copal.

Acatlán's modern ornamental wares began with a spirit of innovation, and they are constantly in a state of transformation. Today the evolution continues, infusing the potters with a creative daring rarely seen in Mexican pottery centers.

The Valley of Oaxaca (Oaxaca)

To comprehend the peculiar geography of the Valley of Oaxaca one should see it from the air. Approaching from any direction, the land appears illogically crumpled, and it is only moments before landing that a small green and lush valley, scarcely fifty kilometers in length, pops into view. One has the startling impression of a well kept putting green on a golf course without fairways.

For centuries, the valley has been a choice and chosen land. The energetic Zapotecs controlled it long enough to build their mighty temples at Monte Albán, only finally to share it, hostilely, with the equally vigorous Mixtecs. Weaker tribes were held at bay until half a century before the Conquest, when the Aztecs assumed nominal control and established a small colony to ensure their militarily won rights. The steel and gunpowder of Europe upset the Indian balance of power, and in 1529 the Spanish throne named the conqueror Hernán Cortés the Marquis of the Valley of Oaxaca.

Today Oaxaca is Mexico's most Indian state, and its citizens take much pride in their heritage. They remember that Benito Juárez, a Zapotec, and Porfirio Díaz, a Mixtec, both rose to the presidency of the Republic. The ties

82

to the Indian past are strong in the valley, especially with regard to its pottery. Although in the capital, Spanish and other late influences dominate, outside forces rapidly diminish with distance from the city.

In the city of Oaxaca itself, only one workshop specializes in decorative wares of any distinction. Here the potters have attempted to adapt decorative motifs from the archaeological sites of Monte Albán and Mitla to their wheel-thrown forms (Plate 10). Other wares made in the capital, while decorative, are completely nondescript.

Santa María Atzompa, the pottery village nearest Oaxaca, produces domestic wares with a characteristic green glaze. Although these pieces are fired in the open-top kiln, they are formed almost exclusively on a variation of the mobile base, the ancient *kabal*. A small amount of unglazed wares is also made, along with a few hand-modeled toys and small figures for such occasions as Christmas and Holy Week. Some potters looking to the tourist market have begun to specialize in these items, and one potter (who is discussed in the section on artists) has become internationally famous for her highly imaginative and expressive figures.

Only one Atzompa form seems to have its origins in traditional ceremonial wares, the *chivo de chía*. Originally designed for springtime votive offerings, the *chía* began as a miniature but in recent years has grown to several feet in height and is now purchased as a garden sculpture (Plate 11).

Slightly farther from the capital, San Bartolo Coyotepec reflects to an even greater degree its Indian background. Coyotepec's specialized subterranean kilns are an essential part of its present production methods, but other techniques are pre-Hispanic. Prototypes of the burnished black surfaces for which the village is famous today have been found in the excavations at nearby Monte Albán, and a few modern forms are virtually identical with ancient ones.

While for some time the traditional market for Coyotepec's *corriente* has been declining, in recent years its pottery production has increased, probably because of the extension of the Pan American Highway through the village. Potters have responded to the greater exposure to tourists by converting old but beautiful utilitarian wares to new and ornamental ones.

The Río Balsas (Guerrero) Area

On almost every holiday thousands of Mexicans flee Mexico City. For many, their destination is the fabled "jewel of the Pacific," the Latin darling of the international set, Acapulco. They pause only for gasoline or soft drinks as they dash across the State of Guerrero, for the lifeline of pavement they follow traverses some of central Mexico's most barren and brutal terrain, the Balsas-Mexcala depression.

Here the deeply eroded land contains little arable soil or mineral wealth. Recalcitrant rebels, guerrillas and bandidos, infest the sterile hot countryside, and the bulk of Guerrero's 125,000 Indians, barely touched by the twentieth century, live here. Many are illiterate, and they speak almost extinct Indian languages.

Although the Balsas-Mexcala area is rich in cultural and historical remains, for the most part archaeologists and anthropologists have ignored it. For the foreign potter it is a gold mine. Here the Indians fire their pottery in open bonfires, just as their ancestors did. Even alongside the Mexico City-Acapulco highway, open since 1927, in the village of Zumpango del Río we found backcountry pre-Conquest pottery techniques. While Zumpango pottery reflects outside influences and current market demands, its forms and decorations suggest its timeless precursors.

A small quantity of this pottery finds its way to Mexico City shops, but more is sold through highway stands in Xalitla and the weekly market in the state capital, Chilpancingo (Figures 84–87). Local Indian village markets still exist, where the unchanged *corriente* vessels, *pichanchas*, *tinajas*, and *cántaros*, are still sold; over the centuries life has changed little for these people. Other potters of the Río Balsas area have uncovered a more lucrative outlet, furnishing planters to city dwellers and ornamental items to tourists.

The easily identifiable decorative style of this region, suggestive of the bark-paper (*amate*) paintings familiar to every tourist, is applied with great imagination to such things as Ameyaltepec's functional planters and Huapan's stately, vaguely Oriental, king and queen figures. Similar works, differing only slightly in form and decoration, come from more inaccessible areas such as Tulimán.

Figure 84. Pottery from the Balsas-Mexcala area reflects a strong Indian heritage. While potters here use pre-Conquest techniques, decoration is greatly influenced by outside forces, particularly the *amate* bark painting. In our view, when the painters began decorating pots in gaudy and tasteless colors they lost points. But the results of the competition between painters and potters have been salubrious where potters continue to do their own decoration. Large jar from the Tulimán (Guerrero) area, photographed in the *Museo Nacional de Artes Populares e Indústrias*, Mexico City, 1971.

Figure 85. The new style has been applied with great imagination to everything, including toys and piggy banks. (The piggy banks shown are from the authors' collection; both are from Huapan. Each measures 22 cm in height.) Huapan, Guerrero, 1972.

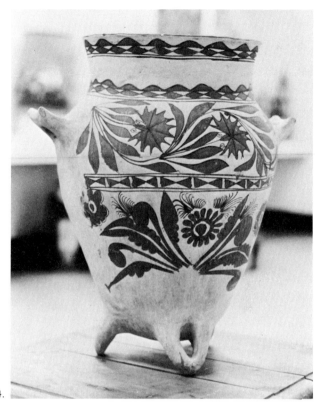

84.

85.

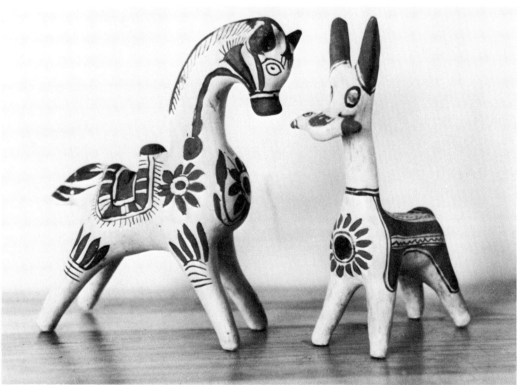

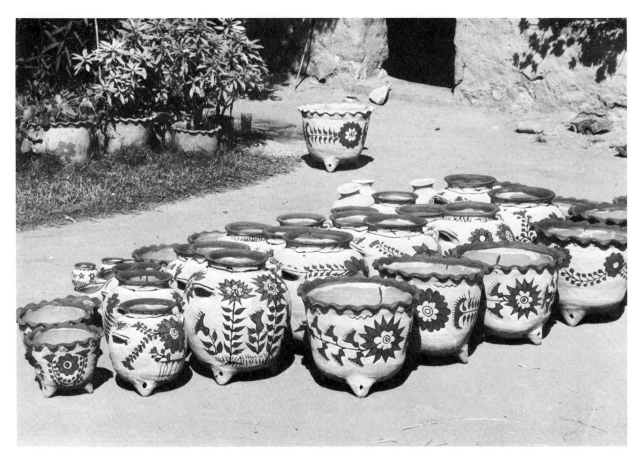

Figure 86. Functional planters in the patio of the Francisco Pastor family, Zumpango del Río, Guerrero, 1972.

Although the Xalitla-Ameyaltepec-Huapan district has made the geometric bird and flower motifs for at least half a century, earlier designs were simpler and more crudely painted. Less than twenty years ago an enterprising artisan began importing and decorating the *amate* paper with brilliant commercial colors, basing his decorations on the venerable flora and fauna designs of local pottery. As the bark-paper paintings became more intricate, they in turn influenced the painters of clay pieces. Although the potters continued using their original fired-on colors of black, red, and buff, their work exhibited a freshness in decorative design and execution (Plate 12).

Then a third, and unfortunate, step took place. In Xalitla on the superhighway, energetic painter-vendors, hoping to attract increased tourist trade, began to purchase undecorated clay pieces from nearby villages and to

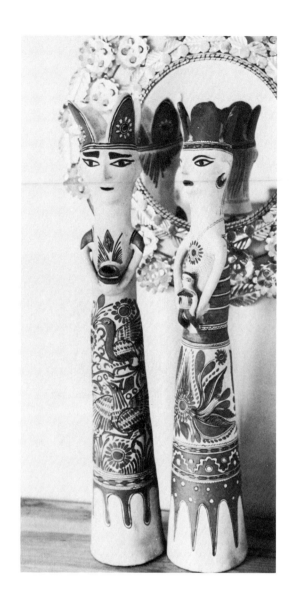

Figure 87. Stately king and queen figures. Huapan, Guerrero, 1973 (Approximately 90 cm in height, the figures are buff clay with red and black decoration.).

paint them with the garish aniline colors used on the bark-paper paintings. The disastrous result has been the loss of the indigenous feel of the pottery, with its evocation of an unknown past. Happily, a few potters continue to do their own decoration with the time-proven colors.

Despite outside influences, the ornamental ware of this region is a vigorous, lovely folk art which draws strongly on the potters' Indian legacy. The recent style of slip painting has been sensitively adapted to a variety of forms, and while it is extremely ornate, it is well suited to the decoration of pottery.

San Juan Metepec (State of Mexico)

Although automobiles now speed from Mexico City to Metepec in an hour, the two-mile-high mountain pass between the two is formidable. With this natural barrier separating them, the Aztecs did not bother to conquer the Matlanzincas of the Valley of Toluca until 1467, and then simply to demand tribute.

The Spaniards, on the other hand, lusted for the land and quickly conquered the valley Indians, destroying their center of Toluca and its satellite village Metepec, and later rebuilding them both in the colonial manner. By 1565, the footpaths from Mexico City to Toluca had been replaced by a wagon road, and only twenty years later the church in Metepec was described by one writer as "small and old."

The landscape of Metepec is sere. At times the midday sun can be punishing, but at others piercing mountain winds chill the high valley towns. A thousand years of woodcutting have all but denuded the area, and the few trees offer no protection from the winds. Despite all this, it is not an unfriendly land: the summer rains bring life to the fertile soil, and during the long dry season pottery can be made (Plate 13).

A deposit of plastic clay lies only seven kilometers from Metepec, and while wood for fuel is dear, it can be had from the pineclad mountains to the east. The proximity of Mexico City, and the ease of transportation to other outlets for ornamental pottery, have made it possible for some potters to achieve a degree of affluence, owning their own trucks and marketing their wares in the city. Some even carry their ornamental pottery directly to the U.S. border.

Our best informed guess is that the production of the decorative wares for which Metepec is internationally known began about the middle of the nineteenth century and, not surprisingly, started with a combination of Indian-Spanish religious motifs. Some early pieces were crèches in elaborately decorated and brilliantly painted candelabra shapes. Out of these candelabra the present powerful and intricate trees-of-life have evolved (Plate 14). Many illustrate passages from *Genesis*. Expelled from Paradise, Adam and Eve hover shamed at the base of the tree; through the branches the

seductress-serpent twines its way; and at the top a fierce and magnificently bearded God-figure gazes somberly at the erring humans below. The religious imagery, interwining the symbols of good and evil, is unsurpassed in Mexican ceramics.

There are other religious themes in Metepec's trees-of-life and in its ceramic sculpture—Noah's ark replete with animals of all kinds, St. James the Apostle astride his rearing horse, grotesque skulls for the Day of the Dead, crowing cocks for Easter, and ornate yoked oxen to celebrate the spring planting festival of San Isidro Labrador (Figures 88, 89). Mythology, too, furnishes themes for village artisans. There are *sirenas* or mermaids, winged

Figure 88. Metepec, by virtue of both quantity and variety, is one of Mexico's most prolific pottery towns. Its clay sculptures range from crudely modeled but often aesthetically powerful mythical animals to relatively sophisticated religious figures. Roof decoration, *Taller de Heriberto Ortega*, Metepec, State of Mexico, 1972.

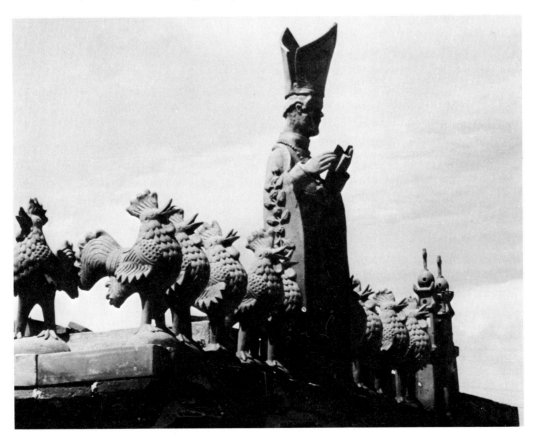

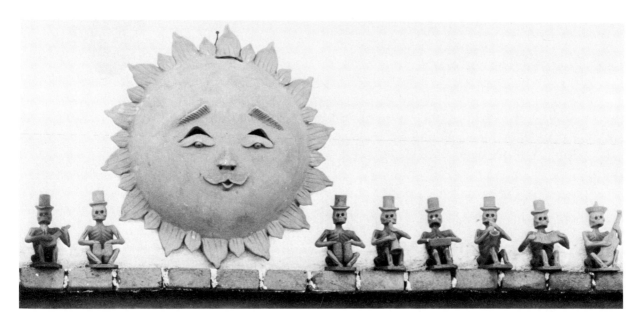

Figure 89. Decorative wall plaques and macabre toys for the Day of the Dead are also made. *Taller de Heriberto Ortega*, Metepec, State of Mexico, 1972.

horses reminiscent of Pegasus, and strange gargoylelike animals, all painted in Metepec's raucously brilliant pinks, purples, and golds.

Dolores Hidalgo *(Guanajuato)*

Little more than fifty years after the voyages of the Niña, the Pinta, and the Santa María, Spain began bleeding the Mexican earth of her precious metals. Spaniards discovered silver in Zacatecas in 1546, and only a few years passed before they ruptured the Guanajuato mother lode, spewing forth the richest treasure in all Mexico. The opening of the mines broke the ground for the Hispanization of all central Mexico.

The wealthy Spaniards of Guanajuato, growing ever wealthier through the forced labor of thousands of Indian miners, demanded products to which they were accustomed. They scorned the native crafts and imported their own craftsmen. With the craftsmen came the medieval guild system, which not only satisfied the immediate demand for Spanish-style goods, but also ensured that no native artisan could reach the top in the craft hierarchy. The result was that the cross-fertilizing influence of the ancient Indian heritages

on the design of ceramic products was completely cut off. Indigenous potters continued making *corriente* in their own villages, mainly to satisfy local needs, but decorative wares were entirely under the control of the Spanish masters operating Spanish-style pottery factories.

In the early 1800s a village priest, concerned with the poor Indians of his parish, attempted to break this pattern by starting a pottery in a small colonial settlement near the junction of the royal road between Zacatecas and Mexico City and the wagon road to the Guanajuato mines. His "factory" produced decorative wares for the Spanish market, but his workers were Indian. In his seven years in what is now known as Dolores Hidalgo, the priest's impact was strong, and today the town's potters revere Father Miguel Hidalgo y Costilla not only as the Father of Mexican Independence but as the founder of Dolores Hidalgo's major industry.

Behind the high courtyard walls lining the streets of Dolores are some fascinating small potteries. Part of their wares, especially the larger pieces, are press molded, but most are thrown on the potter's wheel. The town boasts a number of potters whose throwing skills equal those of any old-time production thrower of Europe or early colonial America. One man we observed turned out four to six soup bowls per minute, and the production of a hundred cups per hour is commonplace.

Dolores is one of Mexico's principal tile manufacturing centers and produces a wide variety of items: decorated basins and bathroom accessories, intricate tiles with religious motifs for household shrines or roadside chapels, and an infinity of shapes, sizes, and patterns of bathroom, kitchen, and patio tiles.

Both the tiles and the pottery are decorated with traditional floral motifs and are frequently referred to as *majolica* or Talavera-style. Traditionalists consider the work decadent, since Dolores's potters do not adhere to the pure *majolica* techniques (Plate 15). For our tastes, however, the adoption of new materials and methods, coupled with vigorous decorative brushwork, gives the pottery of Dolores Hidalgo a vitality not found in the tradition-bound Puebla Talaveraware.

Our inclusion of Dolores as a center of ornamental pottery is not so much because of aesthetic creativity (indeed we found little evidence of it)

but, rather, because Dolores has produced a number of imaginative leaders in ceramic technology. Eager to improve their products and willing to experiment with new ideas, some of these people are testing and examining untried technical innovations, while at the same time attempting to retain the Mexican feel of their wares (Plate 16).

*Tzintzuntzan (Michoacán) and
the Lake Pátzcuaro Area*

In 1522, almost as if in punishment for his capitulation without a fight, the last Tarascan Indian king was assassinated by the Spanish conquerors. His sprawling urban capital of Tzintzuntzan was broken up and his vast empire systematically destroyed. Thirteen years later the Spanish Crown finally dispatched to the area an elderly and idealistic lawyer, the Bishop Vasco de Quiroga, whose mission was to establish peace and order in the devastated Tzintzuntzan-Lake Pátzcuaro region.

A student of Sir Thomas More, Don Vasco set about imposing upon the subjugated Indians his ideal of a harmoniously and communally ordered society. Local legend has it that he assigned to each lake village a particular craft: one to make hats, another to carve wood, a third to specialize in copper. Tzintzuntzan and its neighbor, Santa Fe de la Laguna, he designated to make pottery. Whether this story of their post-Conquest rebirth is myth or fact, the two villages have a history of making pottery extending beyond written records, and virtually no other Lake Pátzcuaro town produces it. It is obvious, also, from shards unearthed in excavations on the hills overlooking Tzintzuntzan that, long before the coming of the Spaniards, the Tarascans in this region made pottery.

Of the two towns, Tzintzuntzan is the more thriving. In contrast to Tarascan-speaking Santa Fe de la Laguna, in Tzintzuntzan everyone speaks Spanish. Over the years many individuals, private organizations, and government agencies attempting to improve the quality of life in the Lake region have centered their activities in Tzintzuntzan. Generally, these experiments have had little impact, and the inhabitants have expressed disappointment in

the projects. The likeliest explanation for Tzintzuntzan's vitality is that a major tourist route runs through the heart of the village. Its enterprising artisans have lined the paved highway with small shops stuffed with handcrafts. Some are locally made. Some are not. Some are first quality, but many are less than third rate. Still Tzintzuntzan's tourist market booms.

Competition is keen, and Tzintzuntzan potters quickly take up marketable styles from anywhere, from the pineapple forms of San José de Gracia to the smudged blackware of Coyotepec. They even imitate the work of their own pre-Hispanic forebears in various burnished wares; such wares are not so much copies of antiques as they are interesting forms for which there is a demand.

The only modern style that originated in the village is a black-on-white and white-on-black tableware decorated with ingenuous line-drawn lake motifs (Figures 90, 91). Although the start of this style is traceable to the early 1940s and, some say, to one Tzintzuntzan resident in particular, over the intervening years it has become the property of the entire community with many people engaged in its production. Most of the drawings are merely crude and lacking in sensitivity, but others are naïvely charming. A few are outstanding examples of modern primitive art. Since the inception of the style, the motifs have expanded from simple images of Lake Pátzcuaro white fish, long-beaked herons, and childlike rising suns to complicated delineations of every aspect of rural life around the lake.

The Sierra Tarasca (Michoacán) Area

The dust-dry hills south of the lush strawberry fields of the Michoacán town of Zamora are gutted each summer by violent rains. Deep ravines slice the land, and trips by car or truck to Patamban, San José de Gracia, and Ocumicho are spine-jolting ordeals. But for the visitor interested in ceramics the trip is well worth it.

Isolation has permitted, or more accurately, forced the mountain villages to retain much of their Tarascan heritage, including the language. In this forbidding setting, today's Tarascans struggle for survival, just as their

Figure 90. Although Tzintzuntzan produces pottery of many kinds (much of it derivative from popular works made in other parts of Mexico), only one modern ornamental style originated here, a black-on-white and white-on-black tableware using line-drawn motifs to depict rural life around Lake Pátzcuaro. Some of it is naïvely charming, and a few pieces are outstanding examples of modern primitive art. Tzintzuntzan, Michoacán, 1973 (The dinner plate, from the shop of Bernardo Zaldívar, is slip decorated and thinly glazed.).

Figure 91. Slip decorated white-on-black and thinly glazed dinner plate from the shop of Bernardo Zaldívar. Tzintzuntzan, Michoacán, 1971.

forebears did, by marginal farming and by making pottery. Twenty-five years ago, two out of every three Patamban families staved off starvation by making pottery. Despite federal and state efforts in the meantime to aid the artisans, the sierra scene today is little changed and the potter's lot remains hard.

The three pottery villages lie within a ten-kilometer radius, sharing common traditions and current problems. In Patamban, the largest of the three, both *corriente* (mostly unglazed *cántaros*) and glazed ornamental wares are made, but the most important style is one called the *piña*, or pineapple. Business rivalry has led Patamban potters to look upon the work of their competitors with a jaundiced eye. In San José de Gracia, however, where almost all the potters also make *piñas*, and where competition to be innovative is keen, the villagers are still open in their praise of each other's work.

The *piña* is a mold-made covered jar appliquéd by hand with lumps of clay (Figure 92). The lumps vary from crude daubs to delicately modeled leaves, and the pineapple's lid is usually ornate and suggestive of leafy foliage. While the original covered-jar concept has been retained, in recent years the pineapple has evolved from a simple and realistic, though ornate, style to one of endless variations (Figure 93). It is the most rococo of all Mexican pottery.

The genesis of the style is uncertain. Covered jars with thornlike daubs were made in pre-Hispanic western Mexico, but there is little evidence of any relationship with the modern form. More likely, it is a recent development that started in either Patamban or San José within the past thirty years (Plate 17).

In the most remote and the tiniest of the three villages, Ocumicho, pottery traditions are completely different. Until recently, Ocumicho produced large hand-modeled *tinajas*; these have all but disappeared. There is also some evidence that small pieces decorated with crude figures were once made here. The village's current fame, however, stems from its unique animal and devil figures, recent innovations. Today a handful of families create these weird objects, grotesque monsters which evoke the horrors of some Dantesque hell (Plate 18).

Figure 92. Patamban and San José de Gracia, neighboring villages in Michoacán's Tarascan sierra, are noted for a singular decorative style called the *piña*, or pineapple. Señorita Isabel Calixto of Patamban says that her father started the style in 1948 when he modeled this fairly realistic pineapple piggy bank. Patamban, Michoacán, 1973.

Figure 93. Further refinement has led to spirited competition between individual potters to create delicately formed scales and leaves which replace the thorns, and to apply them in a variety of ways. (Photographed before firing in the greenware state, this *piña* by Emilio Alejos Pérez measures forty-two by fifty-eight centimeters.) San José de Gracia, Michoacán, 1973.

Plate 21. Tonalá's ceramics are more diversified. Both glazed and burnished wares in a wide range of forms and decorative styles are produced. While *botellones* similar in shape to those of El Rosario, but decorated in a very different manner, may be found, other forms such as this very large covered jar are finished in a fashion similar to that of El Rosario and Tatepozco. Tonalá, Jalisco, 1971 (Photographed in the *Casa de las Artensanías de Jalisco*, Guadalajara, the jar stands 125 cm in height.).

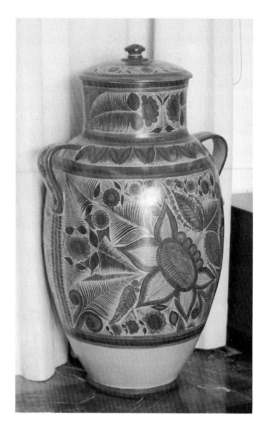

Plate 22. The art of Tonalá is essentially that of the painter, and one of his most important idioms is the *petatillo*. A worker in the pottery shop of José Bernabe lays in the crosshatch background from which the name *petatillo* derives. Tonalá, Jalisco, 1971.

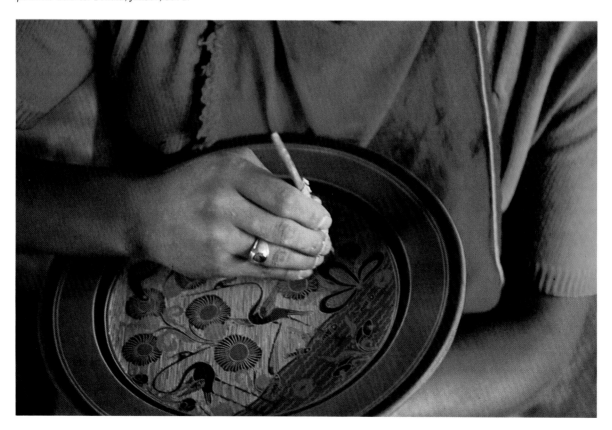

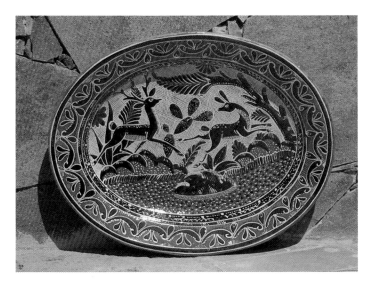

Plate 23. The canons of *petatillo* painting restrict the palette almost entirely to black, white, brown, and green, but occasionally a refreshing maverick substitutes blue for green. Tonalá, Jalisco, 1971 (The platter, 38 cm long, was painted by Claudio Díaz Pérez.).

Plate 24. In contrast to *petatillo*, Tonalá's *bruñido* has a soft pastel appearance, and grays and blues predominate. Like *petatillo*, much of the burnished ware is decorated with Hispano-Moorish flora and fauna motifs, though *bruñido* specialists also use repetitive patterns. (*Bruñido* is treated in more detail in the chapter on artists.) Tonalá, Jalisco, 1971 (Photographed in the garden of the *Casa de las Artensanías de Jalisco* in Guadalajara, this *granada*, or pomegranate, approximates 38 cm in height.).

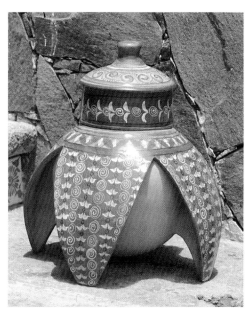

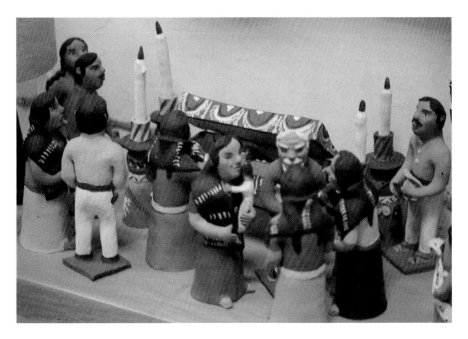

Plate 25. For several generations the Aguilar family of Ocotlán de Morelos in Oaxaca have been recognized for their tableau figures—the celebrations of joy and sorrow —with which every human can have emphathy. Photographed at *Casa Yalalag*, the folk art shop of Enrique de la Lanza, Oaxaca, Oaxaca, 1973.

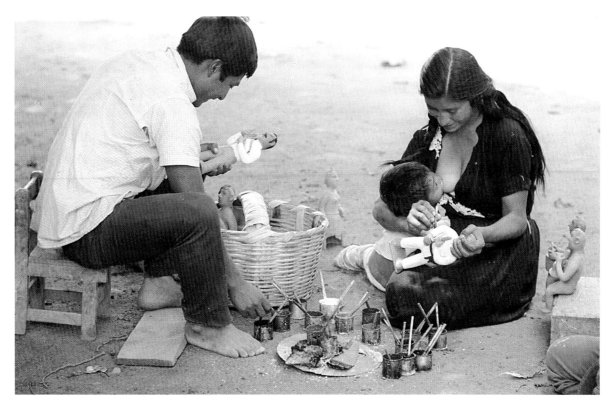

Plate 26. Talented young Josefina Aguilar is carrying forward the family tradition. (Josefina painting musicians for a wedding scene.) Ocotlán, Oaxaca, 1971.

Plate 27. Gorky González, a well-educated modern artist-craftsman from the colonial city of Guanajuato, has chosen to work in an authentic *majolica* technique. His goal is not to imitate past masters but to surpass them. The covered jar by González was photographed in the *Salón de la Artesanía Mexicana* of the *Banco Nacional de Fomento Cooperativo*, Mexico City, 1971.

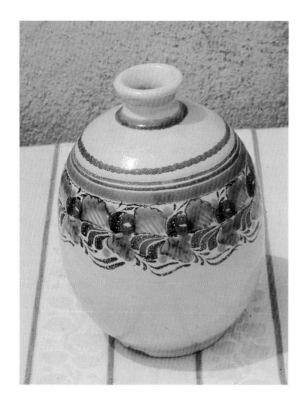

Plate 28. For González himself, however, the personal joy comes from the response of the plastic clay as he sits at his wheel. Guanajuato, Guanajuato, 1973 (Approximately 26 cm high and 20 cm in diameter, the vase is from the authors' private collection.).

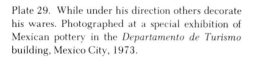

Plate 29. While under his direction others decorate his wares. Photographed at a special exhibition of Mexican pottery in the *Departamento de Turismo* building, Mexico City, 1973.

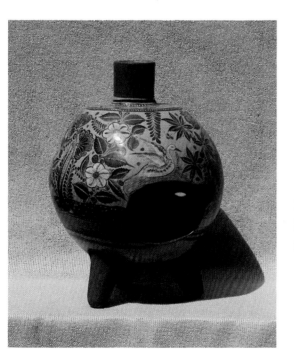

Plate 30. The Jimón family's diverse production includes ornate portable fireplaces (*chimeneas*). Tonalá, Jalisco, 1973 (From the authors' collection, this one measures 51 cm high × 41 cm in diameter.).

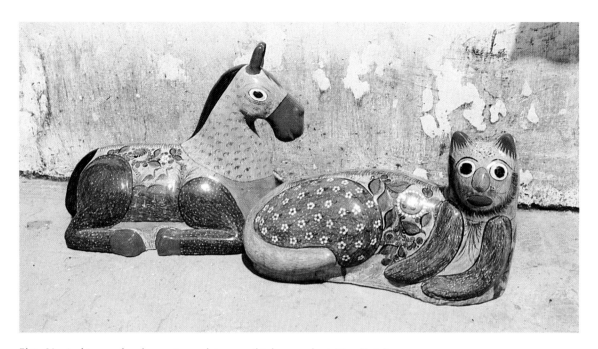

Plate 31. And toys and such amusing sculptures as this horse and cat. Tonalá, Jalisco, 1971 (Photographed in the patio of the Jimón family, each animal is approximately 77 cm long.).

Plate 32. Candelario Medrano of Santa Cruz de las Huertas prefers to remain in the shadows letting his work speak for him. Through clay his language is sprightly, sometimes satiric, sometimes enigmatic, but always strong. Photographed in Señor Medrano's patio, Santa Cruz de las Huertas, Jalisco, 1971.

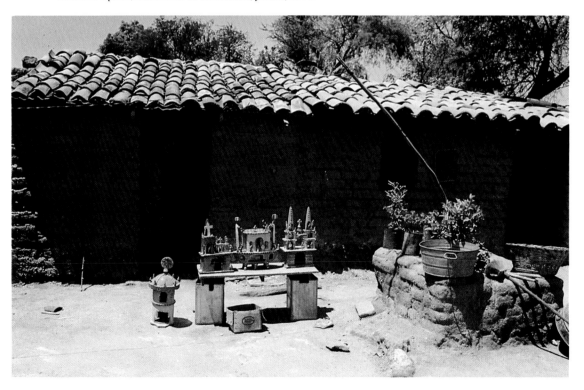

Plate 33. His handling of the medium is direct and spontaneous. (From the authors' collection, the lion stands thirty centimeters.) Santa Cruz de las Huertas, Jalisco, 1973.

Plate 34. Who can define the *personas* crowding Medrano's imagined world of buses, airplanes, and arks? The decks of his boats may be slices of watermelons, while snakes hold the spars topped with Mexican flags. But his toylike images are no more toys than *Alice in Wonderland* is a child's book. Santa Cruz de las Huertas, Jalisco, 1971 (A part of the authors' collection, the boat stands 46 cm high and is 51 cm long.).

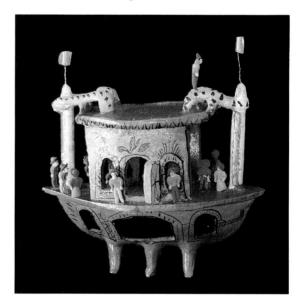

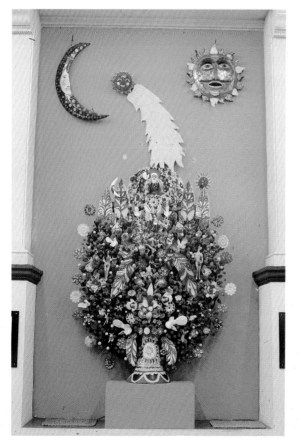

Plate 35. Of the many Metepec craftsmen who make the ornate trees-of-life, none exceeds Alfonso Soteno Fernández in sheer bravado. Photographs of his "trees," like those of the Grand Canyon, cannot reflect the magnitude of both scale and detail. His confidence in handling clay is beyond dimension. This Soteno "tree" is two meters, thirty centimeters high. Photographed in the *Museo de Arte Popular*, Toluca, State of Mexico, 1972.

Plates 36 and 37. The firm sure hand of the master artist-craftsman is revealed, too, in such creations as this fantastic pair of yoked oxen, made by Señor Soteno to commemorate Metepec's special festival of San Isidro Labrador. Photographed in the foyer of the *Cámara de Comercio* (Chamber of Commerce) building, Mexico City, 1973. Estimated height: 2½ meters.

Plate 38. And in this piece for the Day of the Dead. (The skulls are slightly oversized.) Metepec, State of Mexico, 1971.

Plate 39. Press molding, a method familiar to all Tonalá potters, accounts for the bulk of Jorge Wilmot's output, but because of the instruction and training he has given his workers, he now places more emphasis on wheel-thrown wares. (Bowl, fifteen centimeters in diameter, with celadon glaze and reduced copper red decoration. Gift from the artist to the authors.). Tonalá, Jalisco, 1971.

Plate 40. Wilmot is a visionary concerned for his craft and his country, but is also a pragmatist who seeks to lead only by example. While still retaining an authentic "Mexican" flavor, his works meet worldwide technical standards. (A large copper red fish rests on the rim of one of the gold fish ponds in Wilmot's interior patio.) Tonalá, Jalisco, 1971.

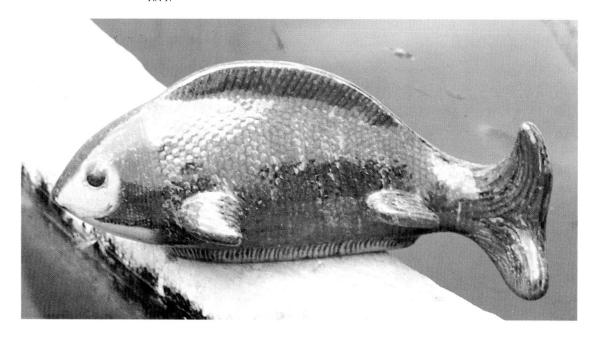

The Tonalá (Jalisco) Area

To the east of Guadalajara, the bustling modern capital of Jalisco, and close enough to be almost a suburb, is a cluster of pottery-making villages. Tonalá, the largest and most prosperous, is in fact a town, but its conservative life-style is that of a rural pueblo from a former era. While the languages of its pre-Conquest inhabitants have disappeared, both the villagers and the city folk think of the Tonaltecans as Indians and "everyone knows" that pottery has always been made there.

Actually, little is known about pre-Hispanic pottery from this area, but examples in the museums of Guadalajara and nearby Tlaquepaque indicate that Tonalá has existed as a vital pottery center for at least two centuries. Other records cite a history of uninterrupted production since the turn of the seventeenth century.

In any event, Tonalá today is a pottery town, with the bulk of its output coming from patriarchal cottage industries. In these family enterprises most of the pottery is sold under the father's name, though a few women are now recognized in their own right. In some families everyone from the youngest child to the oldest adult participates in a loosely organized production unit, interchanging jobs within the limits of individual strength and talent. In other families some members work at other jobs, either hiring out to other potters or to the town's sole pottery "factory," or seeking more remunerative employment in Guadalajara. Even so, roughly one-third of the population supports itself almost entirely by pottery making.

We found Tonalá unique. It was the only area we visited where children of pottery families appear to be continuing the family craft by choice. As elsewhere in Mexico, the younger generation learns the craft by imitating their elders, and innovations by the young are discouraged. Changes must be initiated by the father or an older person, and new designs, once developed, become family property. Older designs are generally considered public property, but the new ones remain the family's domain for several generations. There may be some diffusion through intermarriage between pottery families.

These unwritten copyright laws also extend to many of the older forms

and decorative styles. While to fill a special order many potters will make anything within their ability, they prefer to avoid abrasive competition with other neighborhoods. By long-standing custom, the nearby villages of El Rosario and San José Tatepozco, as well as the four pottery sections of Tonalá, generally restrict their output to distinctive forms or decorative styles (Plates 19, 20).

Almost all the area's pottery is press molded albeit the molds are of great range in form and type. Even small animal and bird forms which might be hand modeled elsewhere are mold made, and the potter's wheel is almost never used except as a lathe on which to turn out molds. Some of the more innovative Tonalá families produce a wide variety of shapes, but other families and even some nearby towns limit themselves to a single type of mold. Frequently, the same form appears over and over again, but its designation locally depends upon the surface treatment it has been given.

While Mexican pottery aficionados make much of these various Tonalá decorative styles, the art of Tonalá is essentially that of the painter. All its styles are based on slip painting. Some are finished in the early Spanish manner with a coat of clear glaze, and some in the Indian tradition of burnishing (Plate 21).

Tonalá's two most important styles are the glazed *petatillo* and the unglazed *bruñido.* (The term *petatillo* derives from the crosshatch background of the design, which resembles the *petate*, the woven straw sleeping mat used throughout rural Mexico. The word *bruñido* simply means burnished.) Both styles allow individual inventiveness but only within strict canons. The motifs employed are largely prescribed, but a good deal of latitude is permitted in their arrangement. Color, already restricted by the nature of the medium, is further constrained by tradition.

Petatillo is used only on dinnerware or table-service items, and its painters take great pride in their ability to lay in the background crosshatching with utmost precision (Plates 22, 23). Far more interesting to the foreign eye than the crosshatching is the stylistic treatment of the decorative motifs. These images range from the sweet lyricism of Walt Disney to the romantic fantasies of Henri Rousseau. The use of glaze intensifies the colors of the slip paints and gives a hard, sharp quality to the design, which allows for few

98

mistakes in the brushwork. Real dexterity is demanded. Traditionalists restrict their palettes to black, white, brown, and green, but once in a great while an independent spirit will substitute blue for green. Despite repetition of designs and color, these exuberant paintings have a feeling of spontaneity, and some pieces reflect delightful wit and disarming charm.

Tonalá's *bruñido*, in contrast to the *petatillo*, has a soft pastel appearance, and grays and blues predominate. Like the *petatillo*, much of the burnished ware is decorated with Hispano-Moorish flora and fauna motifs, though the *bruñido* specialists also use overall repetitive patterns (Plate 24). Some of the nineteenth-century works in this technique display a distinctly Middle Eastern or Persian flavor. At present, the most popular burnished ware consists of vases, water bottles, portable fireplaces, cigarette boxes, and sculptural forms of birds and animals.

The *bruñido* artisans are convinced that the high quality of their polishing is due to the use of their pre-Hispanic iron pyrite burnishing implements (Figure 94). Other tools, they say, tend to smear the delicate

Figure 94. Amado Galván is one of the masters of the *bruñido* style. His burnished vase with repeat floral patterns (from the authors' collection) measures sixty centimeters high. Tonalá, Jalisco, 1972.

designs. As a consequence, an especially fine burnishing tool is truly an heirloom and is carefully passed down from mother to daughter for generations.

For many Mexicans and for many foreigners, Tonalá pottery represents contemporary Mexican ceramics. Even the casual visitor recognizes the *botellones* from El Rosario and San José Tatepozco, and the *bruñido* and *petatillo* of Tonalá, and thinks of them as typically Mexican. He may well believe that all Mexican potters work in these styles. His mistake is logical. Although only a small number of people produce them, in the final analysis, Tonalá wares are very Mexican.

5

The Artists

The great majority of Mexican potters are artisan-craftsmen of varying degrees of skill. There are only a few whom we consider to be artists. What constitutes an artist is not easily definable, but one criterion may well be that the stamp of the creator's personality comes through so strongly in his work that it is readily recognizable. Though the artist is unknown, his art is far from anonymous. Some artists are innovators who strike off into new aesthetic directions. Others may seem to work in the same manner as their peers, but through almost indistinguishable subtleties their art takes on a real distinction. To the practiced eye it can be identified with certainty, and in the parlance of contemporary art critics, it has presence. You cannot look at it without feeling the personality of the person who made it.

The artist, especially the innovator, is a rare phenomenon in all cultures, even in those which place a premium upon creativity. A multitude of workers, whether they call themselves artists or artisans, must be present, it seems, so that the isolated, rare, and authentic artist may eventually emerge. Works of art of a special order appear to come about in much the same way as genetic mutations in nature: some things die a Darwinian death, but others survive to foster a new species.

In parts of the world where the artist is a recognized force, individuals whose art survives become leaders. Other craftsmen, no matter what their medium—paint, bronze, or clay—are merely followers who emulate the

superior work of others. At times these secondary works are very good, and once in a great while, if the emulator has the true creative impulse, his work slowly shifts into a distinctive and personal style.

In the parts of the world where the time-honored traditions of the crafts prevail, imitation is the accepted norm. Individuality and originality are frowned upon, and the person who breaks from the mold, from community-held standards, is looked upon as a maverick. Though the community may tolerate him, he is an outcast from the local society of craftsmen. Standards of quality are based on reproduction of recognized forms, and the community acknowledges as the "best" the artisan who does what everyone else is doing, but who does it more efficiently. The innovator is rarely followed, unless his work proves to be a financial success.

The artist must be dedicated to his work and have a thorough command of his medium. Ultimately, he must possess the elusive "creative spark." Of the hundreds of Mexican potters with whom we have had personal contact, only a few seem to us to qualify as artists. Undoubtedly there are others whom we did not meet, and still others who have not yet found their way. The following people are exceptional, and their works carry the special stamp of their creators' personalities. They are presented here in alphabetical order.

Josefina Aguilar of Ocotlán de Morelos, Oaxaca

When a ceramic style runs in a family for several generations, there is a tendency, both within the family and outside it, to compare the work of a younger member unfavorably with that of a parent, a grandparent, an aunt, or an uncle (Plate 25). This is especially true when an obviously talented young person begins to show signs of artistic independence, though the deviations from family traditions may be minor. Often this becomes cause for family strife, and only a strong personality can resist the pressures to continue duplicating older works (Plate 26).

While it is still too soon to say if her talents will prove outstanding, Josefina Aguilar is just such a rising and maturing young ceramist. Un-

doubtedly, she will continue to make many pieces in the family style: bells in human and animal forms, bird-shaped candelabra, and the famed Aguilar multifigured scenes of such important events in life as weddings and funerals (Figure 95).

But Josefina has begun to devise new forms. The unusual chess sets of clay which she started making in 1973 reveal the special and personal mark of the artist (Figure 96).

Teodora Blanco of Santa María Atzompa, Oaxaca

Teodora Blanco is an unassuming but self-assured artist who, but for a few minor twists of fate, might well have become just another anonymous potter (Figure 97). She replied to our questions about her life and work with

Figure 95. "Mourning Lady," by the family of Jesús Aguilar, Ocotlán, Oaxaca. From the private collection of Dr. Paul V. Love, Scottsdale, Arizona. Photographed in Okemos, Michigan, 1972.

Figure 96. The chess sets, which Josefina Aguilar started making in 1973, while lacking the drama of the tableau figures, reveal the special and personal mark of the artist. Ocotlán, Oaxaca, 1973 (From the authors' private collection.).

Figure 97. Although Teodora Blanco has rarely left her native village of Atzompa, she has achieved world fame as a ceramic artist. Her Zapotecan heritage shows as clearly in her work as in her portrait. Photographed in her home, Atzompa, Oaxaca, 1971.

sparkling humor, sprinkled with earthy Zapotecan phrases which we under-stood only by inference.

While hers is a pottery background, by Atzompa standards her family was well-to-do; her father was a farmer who owned his own land. Because of the family's affluence, Teodora's childhood differed from that of other children in the village. Two things in her early years seem to have influenced her work. She was not pushed into making pottery to supplement the family livelihood but was permitted to continue her clay-play a bit longer than other children. Because her family had connections outside Atzompa she made frequent trips away from home. Many of her pieces stem from impressions of things she observed as a child in the state museum of Oaxaca.

As she entered her teens, when most of her friends already had become part of a family pottery production team, she invented some charming toys, delightful animal musicians, which found a ready market in the state capital of Oaxaca and soon became known outside the region. While she continued to make ashtrays and other items, it was her amusing musicians that led to the sculptural works that have earned her an international reputation.

Her twenty-four-piece nativity scenes are wondrously versatile: the Virgin Mother wears a Mexican *sombrero*, and the Three Kings ride toward the Star of the East astride an elephant, a camel, and a burro. Her death figures are stark and powerful, and their origin, no doubt, lies buried in Teodora's Indian heritage. Art historians of the future, however, may well conclude that Teodora Blanco's greatest creative works are her anthropo-morphic surrealistic figures, incredible beings in human forms but with animal heads, and human figures from whose stomachs and hearts weird animal faces project (Figures 98–100).

Gorky González of Guanajuato, Guanajuato

The son of Don Rodolfo González Villarreal, Gorky González lives in a beautifully appointed colonial Spanish residence in the capital city of Guana-juato. His education included two years of study in Japan with one of the great masters of Oriental pottery, Kei Fujiwara. In 1970, at the request of his

Figure 98. Her nativity scenes captivate the eye with naïve details. Atzompa, Oaxaca, 1972 (The pieces shown are part of a twenty-four piece crèche, a gift by Mrs. Jesse Ewing Seaman to the permanent collection, Kresge Art Center, Michigan State University.).

Figure 99. And her death figures are stark and powerful. No doubt their origin lies buried in her Indian heritage. Atzompa, Oaxaca, 1973 (From the authors' collection.).

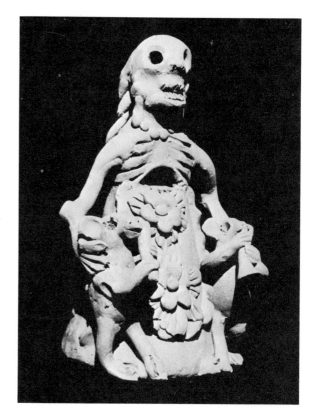

Figure 100. But it is for her surrealistic figures whose meaning is hidden—perhaps even to herself—that future art historians may well judge and remember Teodora Blanco. Atzompa, Oaxaca, 1972 (From the authors' collection.).

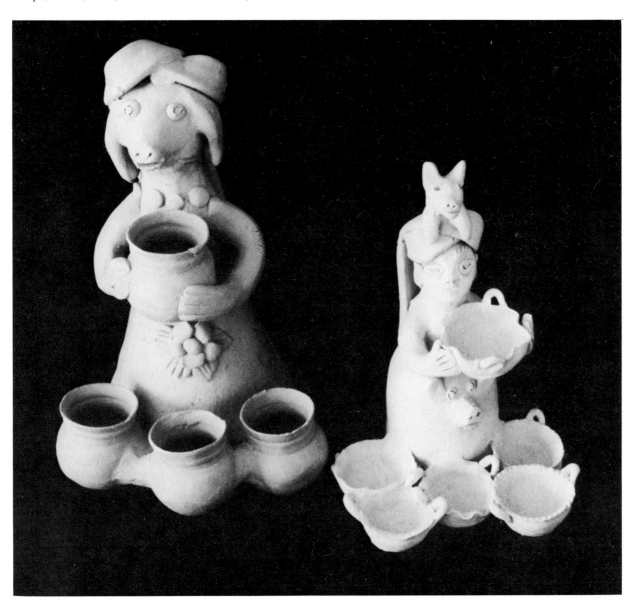

government, he organized the Mexican Exhibition of Arts and Crafts at the World Exposition in Osaka. But for all this, Gorky González is a working potter dedicated to his family's heritage (Plates 27, 28, 29).

Today in the family pottery shop, the *Alfarería Tradicional de Guanajuato*, Gorky González continues to make the same high quality Spanish colonial *majolica* ware his father did. Unlike the Puebla Talavera potteries, the González shop is small, and each piece receives his personal attention (Figure 101). While he is entirely competent to perform every operation in its making, some jobs he leaves to others; decoration, he says, requires a "person capable of great patience." It is obvious that his own preference is the

Figure 101. Gorky González's research into the historical methods of *majolica* production has led him into the preparation of his own materials. (A González worker calcines lead and tin ore to be used in the glaze.) Guanajuato, Guanajuato, 1971.

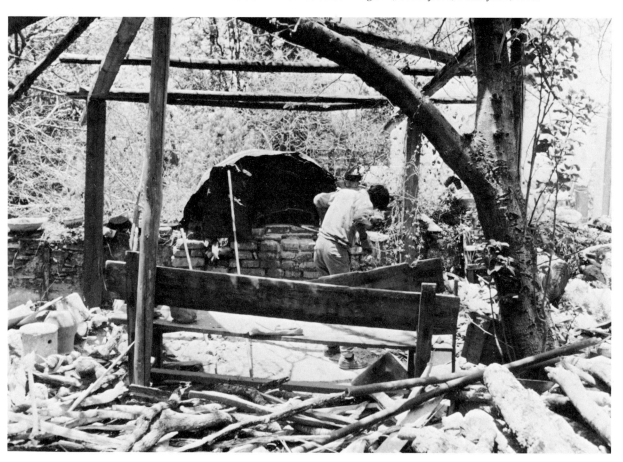

visceral reaction that comes from forming vessels on the potter's wheel for, as he told us, throwing requires *"palpitaciones."*

Innovation holds little interest for him, but it would be inaccurate to say that he is simply a reproducer of antiques. His work, rather, is in the time-honored traditions of craftsmanship, where individuality comes from the strength and vitality of the potter himself.

The Family of Pablo Jimón and Gregoria Mera of Tonalá, Jalisco

In family enterprises such as that of Pablo Jimón and his wife Gregoria Mera, where the lineages are intertwined with those of other pottery-making families and where everyone works with clay, it is difficult to determine which members are more than just artisans. The problem is further complicated by the fact that the collaborative family works are sold under one name, usually that of the father and husband. Though a piece may carry the signature of a single individual, it can well be the result of the combined efforts of a number of people. Even when the work is solely the product of one person, it is essential that it be made in the identifiable family style, and the mark of the individual artist must be submerged (Plates 30, 31).

There are a number of families in Tonalá who work as a unit and whose pottery is of the highest category. We have chosen to single out the Jimón family because we came to know them best, and because we greatly admire their work.

Every member of the family participates in the production of *bruñido*—Pablo, his wife Gregoria, their son Juan, and their daughters Felícitas and Onésima. Pablo himself has long been recognized as a master of the difficult *bruñido* style. Examples of the family work are part of permanent collections in both the Regional Ceramic Museum in Tlaquepaque and the *Casa de las Artesanías de Jalisco* in Guadalajara.

The Jimóns are a famous pottery family; the late Zacarías Jimón was one of Tonalá's outstanding potters of the past generation (Figure 102). During the post–World War I years he invented a lovely pomegranate form with four

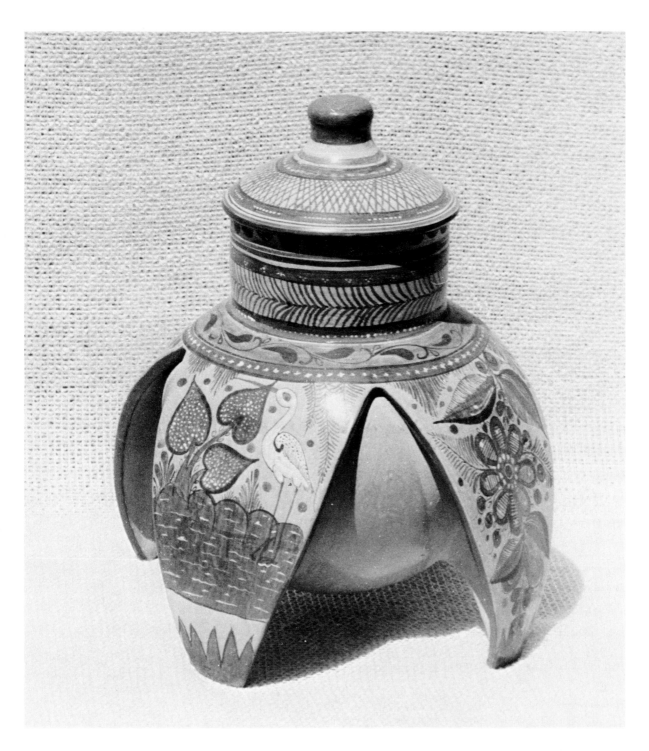

Figure 102. Like his father Zacarías, Pablo Jimón is a master of the Tonaltecan *bruñido* style. The Jimón family, like many other Tonalá pottery families, work as a unit, and one cannot always say with certainty which member did what on a particular piece. Despite this, each family's work has a special individuality. About the time Pablo was born his father designed a lovely form known as the *granada*, or pomegranate. Today in the family only Pablo's sister makes the *granadas*, and his wife, Gregoria Mera, decorates them with her unsurpassed brushwork. (The one shown here, from the authors' collection, is twenty-eight centimeters high.) Tonalá, Jalisco, 1972.

fragile petals. Today in the family only Pablo's sister produces this form, while Gregoria Mera does the painstaking flora-fauna decoration (Figure 103). Gregoria herself has been painting *bruñido* for over forty years, and her sensitive brushwork reveals a feeling for her medium which is seldom matched.

Teodoro Martínez Benito and María Guadalupe Alvarez Sánchez of Ocumicho, Michoacán

The present small fame of Ocumicho stems entirely from its strange and sometimes powerful clay devil figures, images to strike terror into the heart

Figure 103. Partially shaded by a papaya tree, Gregoria Mera de Jimón packs some of the family's production—*botellones*, plates, and cigarette boxes—for a buyer. Tonalá, Jalisco, 1971.

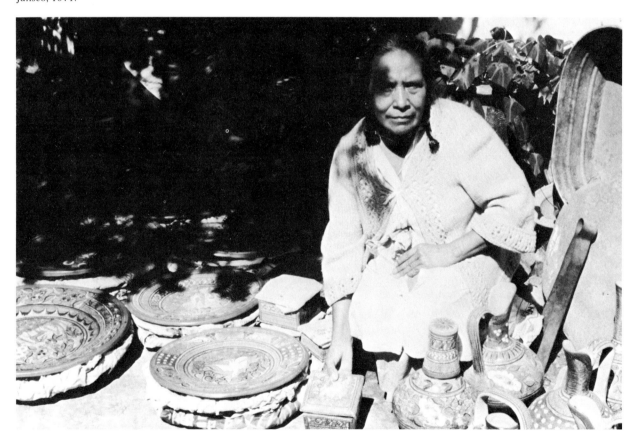

of a sinner. Much of this fame is attributable to Teodoro Martínez and his wife, although they did not originate the style (Figure 104).

The creator of these grotesque monsters, a young man and a close friend of Teodoro's, died in 1966, and although a few other people in Ocumicho were working in the same style, the dead man's clients came to Teodoro and inquired if he could do the same kind of work. He replied that he could. Up to that time he had been a wood carver, but he felt sure that he could devise any form he wished in clay.

The intervening years have proven him right. Moreover, his wife, María Guadalupe Alvarez, seems equally talented, and they constantly interchange work on the devils. There is no discernible difference between her work and his.

Their forms change constantly, according to the whim of the moment, or the demands of a particular client. When we visited them they showed us a variety of devils and monsters, and then a piggy bank in the shape of a turtle

Figure 104. Teodoro Martínez Benito and his wife, María Guadalupe Alvarez Sánchez, of Ocumicho in Michoacán work as a team, freely interchanging places regardless of whether their medium is clay or embroidery. Photographed in front of their home, Ocumicho, Michoacán, 1973.

for one client, and a bitingly satirical revolutionary soldier for another. Most of their pieces are painted, and at times the colors strengthen the impact. Our own preference, however, is for the warm brown tones of the natural clay, which more clearly define the strong direct modeling of the figures (Figure 105).

Herón Martínez Mendoza of Acatlán de Osorio, Puebla

Herón Martínez is not a simple man. He exudes the self-assurance of a born leader, the imagination of a child at play, and the confidence of a sculptor who dares to do monumental work (Figure 106).

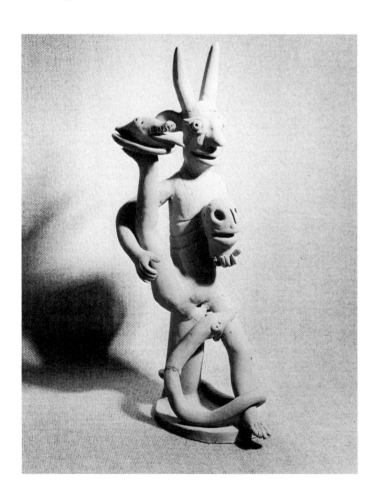

Figure 105. Their best known creations, however, are their ogre and devil figures of clay. Though most are painted in bright colors, our preference is for the warm brown tones of the natural clay which more clearly define the strong direct modeling. "Bedeviled Devil," from the authors' collection. Ocumicho, Michoacán, 1973.

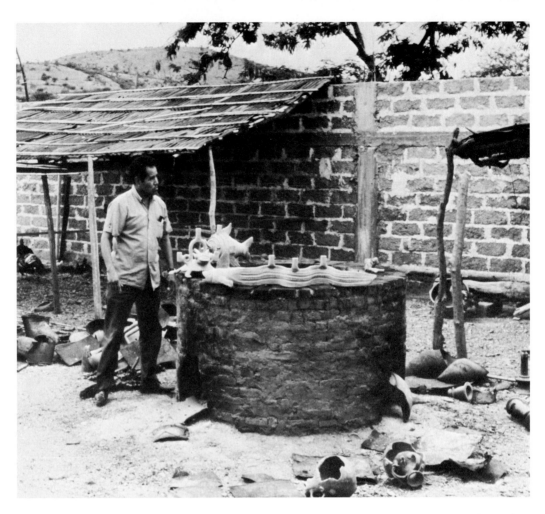

Figure 106. Herón Martínez Mendoza, an artist of immense talents, is the guiding force behind Acatlán's spirit of creativity. Work from his shop includes everything from traditional classic *corriente* to sheer fantasy—sculptured figments of his own fertile mind. Señor Martínez was photographed in his patio-shop, Acatlán, Puebla, 1971.

Both his father and his grandfather were potters, and he learned to make pottery as a child. As a youth, however, he found it more profitable to bring water by burro to his parched village than to work as a potter, and it was not until he contracted with a handcraft store in Oaxaca to act as their Acatlán purchasing agent that he returned to pottery.

Many of the town's potters now work for him, and he has purchased considerable real estate within the village, including some choice hillside building sites. He dreams of making Acatlán a major tourist resort and of

coaxing the government to excavate the ancient Indian ruins which he is sure exist nearby.

But he is more than an astute businessman and more than a dreamer; he is an innovative and creative force in the village. Many potters, both those who work for him and those who do not, copy his work. There is in Acatlán a spirit of creativity which may be traced to his dynamic leadership, and some of the young potters now show promise of becoming artists.

The technical feat of constructing trees-of-life of gigantic proportions (up to three meters, thirty centimeters in height) has brought Herón Martínez his greatest fame in Mexico. But his explorations of other forms, his strange insects and his unreal animals, are far more exciting. Some of these, though highly stylized, are based on recognizable life-forms. Others are sheer fantasy, sculptured figments of his own fertile mind (Figures 107–10).

Figure 107. Small ceremonial planters are transformed through his hands into chest-high whimsical pieces for the garden. Photographed in Señor Martínez's patio-shop. Acatlán, Puebla, 1971.

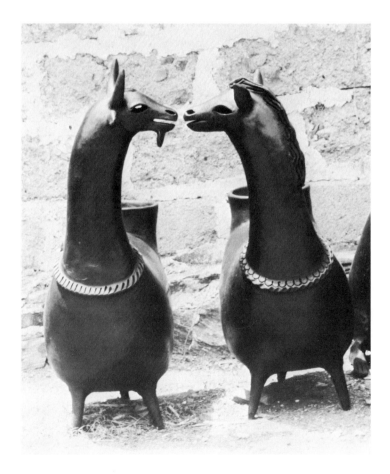

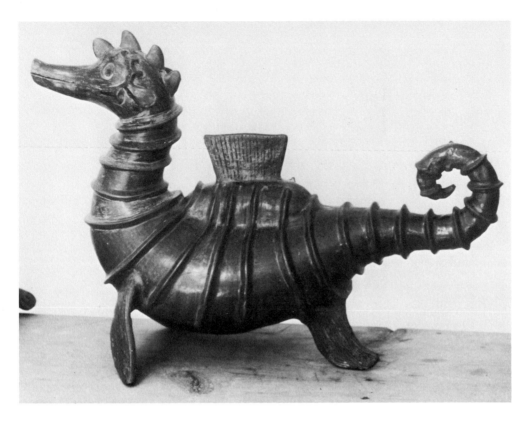

Figure 108. He explores many forms—nameable, playful things. Acatlán, Puebla, 1971.

Figure 109. And nameless, nightmare creatures. Acatlán, Puebla, 1971.

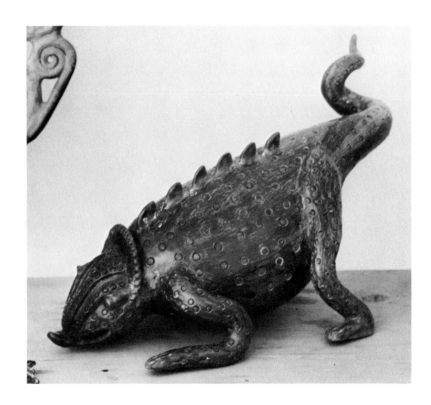

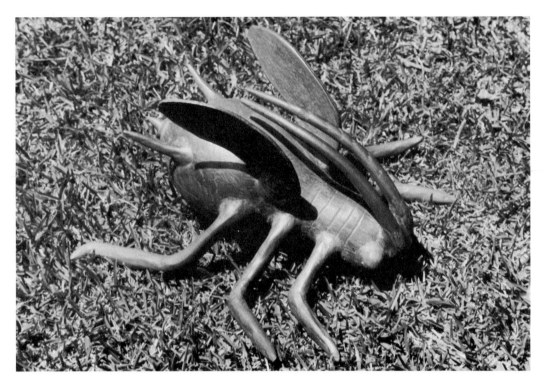

Figure 110. And incredible insects. All exhibit his originality and innovative strength. Acatlán, Puebla, 1971 (From the authors' collection, the bug is approximately 46 cm in length.).

Candelario Medrano of Santa Cruz de las Huertas, Jalisco

A child of Mexico's epic Revolution, Candelario Medrano, like many of that schoolless generation, is illiterate. Yet he is one of the country's enormous artistic talents. For much of his life he supplemented his meager income as a woodcutter by fashioning pottery toys which he sold by the dozen for centavos (Plates 32, 33, 34).

Middle age had already caught up with Medrano when Jorge Wilmot, recognizing his inherent talents, encouraged him to make different things, to use his inborn gifts for greater flights of fancy. The friendship of the two men has continued over the years. Their eyes light up when they speak of each other—Wilmot's at times in anger because his friend, though artistically recognized, is very little better off financially as an artist than he was as a woodcutter, and Medrano's because Wilmot is his patrón and his amigo.

Candelario Medrano's work has frequently been labeled surrealistic, but this is a word he would not understand. His images are sometimes satiric, a term his humble spirit would not accept. But these are interpretations (Figure 111). His language is that of his simple medium, clay. Even those members of his family who work with him scarcely understand his meaning. The tiny forms with which he fills his arks, airplanes, buses, and churches he calls *personas*, while others refer to them as "painted figures."

Who is to decipher the meaning of his Mexican flags flying proudly over a Noah's ark or a Trojan horse? Who is to define his meaning of a lion with a human face? And who is to say the meaning of the song of a bird?

Figure 111. Though often small, the sculputre of Candelario Medrano has the sense of monumentality—but who is to decipher the meaning of the strange animals and mythical beings which fill his mind's eye? Santa Cruz de las Huertas, Jalisco, 1971.

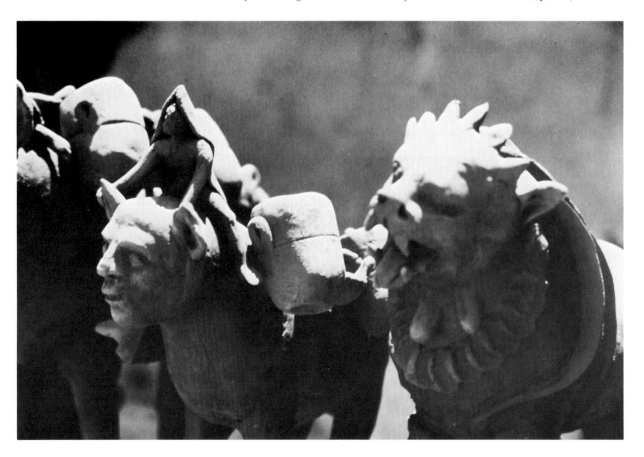

*Alfonso Soteno Fernández of San Juan
Metepec, State of Mexico*

Alfonso Soteno is the acknowledged master creator of Metepec's mammoth trees-of-life. Measuring two meters, forty centimeters, the Soteno trees are at least half a meter larger than any others made in the village; only those of Herón Martínez of Acatlán, Puebla, rival them for magnitude (Plates 35, 36, 37, 38).

Working with Soteno in his shop are two of his brothers and three young helpers, but their belief in what they can accomplish with clay is beyond dimension. Alfonso does not look upon his technical achievements as remarkable, and he seemed genuinely puzzled that others have not been able to match his work in size. He was sure, he said, that he could make a tree-of-life twice as high as the present ones, but it would be necessary to build it in two pieces—not because of construction or firing problems, but because of shipping difficulties.

Two men labor a full month to construct one of these trees; they work inside the kiln, an area less than two meters in diameter. Guy wires attached to the kiln walls to support the fragile structure further impede the workers' movements, and there is no opportunity to step back "to see how things are going" (Figures 112, 113). The only overall view possible is through the narrow slit of the kiln doorway.

Just as impressive as his trees-of-life are Alfonso Soteno's almost life-size yoked oxen, which commemorate Metepec's carnival-festival of San Isidro Labrador. As with the trees, he decorates the oxen and their yokes with intricate details in stunning colors.

While the oxen and the trees are technical tours de force, size alone is never a criterion for art. Undeniably, the scale of these pieces contributes to their total impact, but the true value is revealed only through their wildly imaginative details.

As every potter knows too well, any of a thousand things may go wrong from the beginning of a piece to its completion. The larger and more complex the piece, the greater the risk of disaster and financial loss. Consequently, the Sotenos turn out a multitude of other smaller ornamental forms, but even in

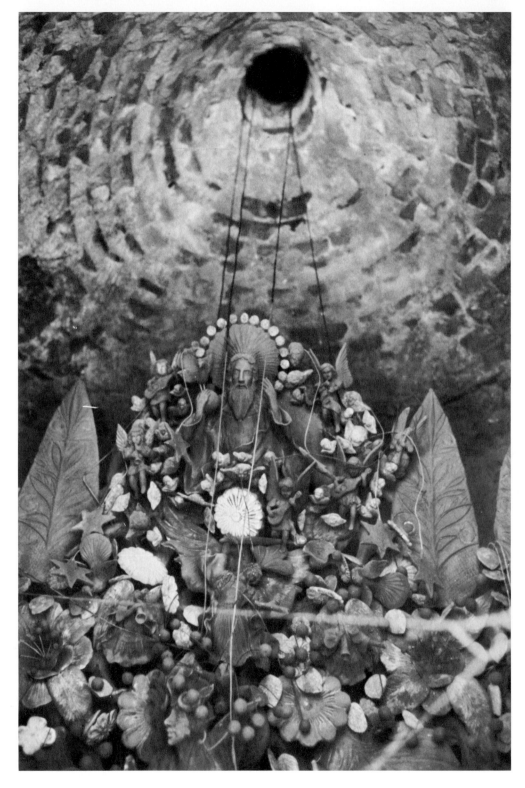

Figure 112. During the construction of a Soteno "tree," which takes two men a full month, guy wires attached to the kiln's inside walls support the fragile structure. Metepec, State of Mexico, 1973.

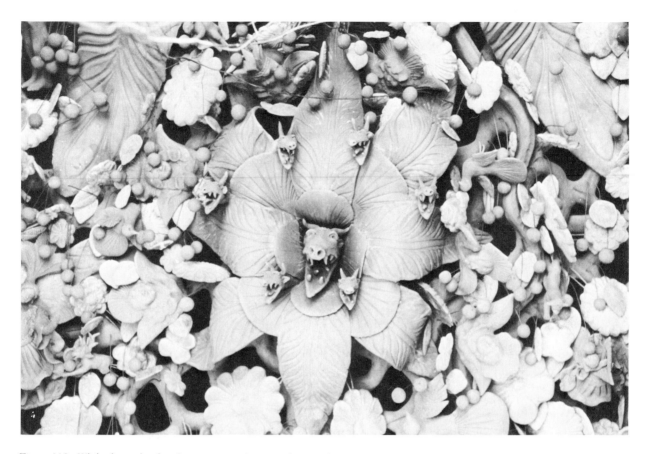

Figure 113. While the scale of such pieces contributes to their total impact, it is the wildly imaginative details which captivate the observer. Many of the smaller adornments are attached by wires embedded in the clay. Photographed inside Señor Soteno's giant kiln, Metepec, State of Mexico, 1973.

these pieces the firm, sure hand of the master artist-craftsman is clearly visible.

Jorge Wilmot of Santiago Tonalá, Jalisco

The strongest "foreign" influence on Tonalá and its pottery in recent years came in the guise of a single individual. Although a Mexican by birth, Jorge Wilmot was an alien in the town's rural village atmosphere. He is a twentieth-century artist-potter, educated in the humanities and well-trained in the techniques and aesthetics of his craft (Plates 39, 40).

His impact on Tonalá has been subtle, for he is not a crusading reformer.

He is, however, deeply concerned for his town, his nation, and the future of the crafts in Mexico. In his view, the changes which are essential for the survival of Mexican handcrafts can come only through individual efforts; they cannot be imposed by "experts" upon people who have no wish to change. The route that Jorge Wilmot has chosen is that of example.

From the exterior the Wilmot shop differs slightly from others in the village. The interior is another matter. Here the layout is thoughtful and beautiful, with decorated arched portals and a serene patio with multileveled pools alive with water lilies and goldfish (Figures 114, 115).

Figure 114. Tonalá's Jorge Wilmot runs his shop in the old manner of a master craftsman who oversees a large number of assistants, rather than in the "studio potter" mode. But he is a twentieth-century artist-ceramist whose distinctive stoneware has brought him international recognition. Tonalá, Jalisco, 1971. (Photographed in Señor Wilmot's interior patio).

Figure 115. Throughout his shop and show-rooms, aesthetics and practicality meld, with special pieces placed here and there. A stoneware bird framed by an arch of an arcade.' Photographed in the patio of Señor Wilmot's shop, Tonalá, Jalisco, 1971.

The showrooms display the breadth of Wilmot's work. Although most of his pottery is high-temperature stoneware, it is made in molds, a technique familiar to his workers. In recent years he has begun to place more emphasis on wheel-thrown wares. Perhaps this is the result of the careful training on the wheel that he has given his employees, some of whom have been with him since the late 1950s when he opened his present shop.

Above the orderly workshop the top floor is reserved as a museum to

display Wilmot's personal collection of Mexican pottery. His museum is well lighted by an ingenious system of concealed skylights, and along one wall large open windows admit a panorama of Tonalá.

In this pleasant setting we had several long visits. Our conversations ranged from heated discussions about the nature of art and the technical problems of ceramic production, to serious debates over Mexico's ceramic past and its uncertain future, and the difficult economic problems of selling handcrafted products in national and world markets. Jorge Wilmot is a visionary whose philosophy is rooted in a concrete knowledge of the modern world as it is. In such men as Wilmot may lie the hope for Mexico's pottery future.

Glossary of Mexican Pottery Terms

Aguardiente. A very strong and inexpensive alcoholic beverage.

Alambre. Metal wire.

Alcancía. Piggy bank.

Alfarería. Place where pottery is made.

Alfarero. Potter.

Amasar. To knead.

Amate (also *amatl*). Bark paper.

Apaxtle. Pottery basin or bowl.

Arcilla. Clay.

Artesanías. Handcrafts.

Artesano. Artisan.

Asa. Handle.

Azotador. Pestle-shaped implement used to flatten the clay tortilla.

Azucarera. Sugar bowl.

Azulejo. Tile.

Bañadero. Birdbath.

Barril. Barrel-shaped vessel.

Barrio. Neighborhood or quarter of town.

Barro. Clay.

Barro blanco. White clay.

Barro colorado. Red clay.

Barro de olor. Aromatic clay.

Barro negro. Black clay.

Base. Foot or base (of a pot).

Bizcocho. The first, or bisque, firing.

Boca. Fireport or stokehole of a kiln.

Bodega. Storeroom or warehouse.

Botellón. Clay water container.

Botones. In U.S. ceramic terms, points (kiln furniture).

Brasero. Brazier.

Bruñido. Burnished.

Bruñir. To burnish.

Caballos. (lit., horses) Stilts, in U.S. ceramic terms (kiln furniture).

Cacharro. Earthenware pot.

Cafetera. Coffee pot.

Cajete. Shallow clay bowl.

Canasta. (lit., basket) In pottery a globe-shaped vessel with one handle.

Candelero. Candlestick.

Cántaro. Pottery vessel for transporting liquids.

Cazo. Large pottery stewpot used principally for making sweets. The *cazo* traditionally should be made of copper, but where copper is short, it is made of clay.

Cazuela. Large pottery stewpot.

Cenicero. Ashtray.

Chimenea. Portable fireplace made of clay.

Chiquihuite. Handleless willowreed basket used to transport fuel.

Chirmolera. See *molcajete.*

Chorreada. Runny.

Cocido. (lit., cooked) In pottery refers to the bisque state (after the first firing).

Comal. Flat, unglazed clay disc used as a griddle for cooking tortillas, the Mexican staple.

Costal. Burlap bag for carrying clay.

Comerciante. Trader or merchant.

Comisionista. Commission merchant.

Cuero. Leather (sometimes used as a scraper in finishing the wet clay piece).

Despintar. To lose color, fade.

Dibujante. Painter.

Dibujar. To paint.

Diseño. A design.

Elote. Corn cob (sometimes used as a scraper in finishing the wet clay piece).

Enfriadera. Large pottery vessel to keep water cool. Also known in some areas as a *cabeza de tinaja.*

Engretado. Glazed or gloss state of the pottery after the second or glaze firing.

Esmalte. Enamel.

Espuelas. Spurs (kiln furniture).

Estrellas. Stars (kiln furniture).

Fábrica. Factory.

Farol. (lit., lantern) In Coyotepec, a perforated pottery form which may be used as a lampshade.

Florero. Flower vase.

126

Frita. Frit.

Frutero. Fruit bowl.

Garrafón. Large vessel for cooling liquids.

Greta. Litharge.

Horno. Kiln.

Huacal. Box in which pots are transported.

Incensario. Incense burner.

Jardinero. Flower stand or jardinière.

Jarra. Clay vessel with a narrow neck and narrow spout and one or more handles; a jar, jug or pitcher.

Jarro. A clay mug or pitcher with only one handle.

Kabal. A turntable without a fixed pivot used in forming pottery and attributed to the ancient Maya. Also known in some areas as *molde, plato,* or *parador.*

Lavabo. Bathroom basin.

Lechera. Milk pitcher.

Leña. Wood used for fuel.

Locero. One who works with clay; a potter.

Loza. Ceramic tableware or fine china.

Loza corriente. Everyday pottery for domestic use.

Loza fina. Well-glazed tableware.

Lustre. Glaze.

Maceta. Planter.

Macetón. Very large planter.

Macho. The central support in the firebox.

Madera. Wood.

Maestro. Master potter.

Majolica. An opaque white, lead-tin glaze.

Mano. (lit., hand) In pottery, pestle.

Masa. Dough.

Mate. Matte finish.

Mecapal. Tumpline.

Media caña. A potter's rib, in U.S. ceramic terms; a tool used in throwing on the potter's wheel.

Metate. A hollowed or concave stone of volcanic rock. It is the indigenous corn-grinding instrument.

Mina. Mine.

Molcajete. Three-legged bowl used for grinding herbs, peppers, etc., and made either of rough volcanic stone or of clay, with deep interior striations.

Molde. A mold; also, in some areas, a variant on the Mayan *kabal.*

Moler. To grind.

Nacimiento. A Christmas nativity scene.

Ocote. Pitch-pine wood used for firing.

127

Olla. A clay cooking pot.

Oreja. (lit., ear) In pottery, handle.

Palo. Wooden bat for pulverizing clay.

Parador. A variant of the Mayan *kabal.*

Patojo. (lit., shoe) A clay cooking vessel resembling a shoe and designed so that the toe may be shoved into a fire burning under the clay griddle (or *comal*).

Pegajoso. Sticky.

Petate. A woven straw sleeping mat.

Petatillo. The crosshatch decoration used by some Tonalá potters. The word derives from *petate.*

Petróleo. Kerosene or oil.

Pichancha. Colander.

Pila. Carbon core of a dry cell battery, sometimes used to burnish pottery.

Piña. Pineapple.

Piñata. A clay jar ornamented with fancy paper and filled with candies and nuts. It is hung from the ceiling so that blindfolded children, taking turns, may break it with a stick. Piñatas are traditionally part of the Christmas celebration and birthday parties in Mexico.

Pincel. A painter's brush.

Pintado. Painted.

Pintar To paint.

Plato. Plate; also in some areas a variant of the Mayan *kabal.*

Platón. A large platter.

Plomo. The metal lead.

Ponchera. Punch bowl.

Puerta. (lit., door) In pottery, fireport or stokehole.

Pulir. To polish, rub, or burnish.

Pulido. Polished, rubbed, or burnished.

Pulque. Liquor prepared from the maguey plant.

Pulverizar. To pulverize or grind.

Quemada. Firing or fired.

Quemar. To fire.

Regatón. Middleman.

Rescatón. One who carries pottery to distant markets to sell.

Rueda. The potter's wheel.

Sahumerio (also *sahumador*). A censer; a vessel in which incense is burned.

Sopera. Soup tureen.

Suelto. Loose.

Talavera. The Spanish-style ceramic dinnerware that originated in the city of Puebla.

Talco. Talc, or steatite.

Taller. Workshop or studio.

Tantear. To estimate.

Tapa. A lid or cover.

Tarea. Task or chore; in pottery, the amount made in a day.

Tarro. Mug.

Taza. Cup.

Tibor. Very large, Ali Baba-sized clay vessel.

Tierra. Earth.

Tina. Large basin, washtub, or bathtub.

Tinaja. Large pottery jar usually used for storing water, but sometimes used for grain.

Tizate. White chalk used as a binder.

Torneado. Made on the potter's wheel.

Tornero. Wheel man.

Torno. The potter's wheel.

Torno de mano. The slow wheel, usually turned by hand.

Tortilla. In pottery, a clay slab.

Triángulo. Triangle (kiln furniture).

Tunal. A form of cactus used as fuel in arid parts of Mexico.

Vajilla. Table service of dishes.

Varniz. A varnish.

Vasija. Vessel to hold foods or liquids.

Vaso. Vase or mug.

Veta. Vein of clay.

Vidriado. Glazed.

Vidriar. To glaze.

Yeso. Plaster.

Bibliography

Academia Mexicana de Arte Popular and Instituto Mexicano de Cultura. *Alfarería Poblano*. Mexico City: Organización Editorial Novaro, 1968.

American Geological Institute. *Dictionary of Geological Terms*. Garden City: Dolphin Books, 1962.

Arbingast, Stanley A., et al. *Atlas of Mexico*. Austin: University of Texas Bureau of Business Research, 1970.

Artes de México. "Guanajuato," Nos. 73/74. Mexico City, n.d.

———. "Vidrio, Cerámica y Metales," No. 8. Mexico City, 1966.

———. "Un Paseo por San Miguel de Allende," No. 139. Mexico City, 1968.

———. "El Campo Mexicano; Comunidades Indígenas," No. 114. Mexico City, 1969.

———. "Riberas del Lago de Pátzcuaro," No. 120. Mexico City, 1969.

———. "El Juguete Mexicano," No. 125. Mexico City, 1969.

———. "Cholula, Ciudad Sagrada," No. 140. Mexico City, 1971.

"Artesanías de Guerrero." Mexico: Talleres Gráficos de la Universidad Autónoma de Guerrero, n.d.

Artesanos y proveedores, 5th ed. Mexico City: Talleres Gráficos de México, 1970.

Artigas, J. Llorens, and Corredor-Matheos, J. *Cerámica popular española actual*. Barcelona: Editorial Blume, 1970.

Atl, Dr. (pseud.; see Murillo, Gerardo).

Augur, Helen. *Zapotec*. Garden City: Doubleday & Co., 1954.

Bernal, Ignacio, with Piña-Chán, Román and Cámara-Barbachano, Fernando. *Three Thousand Years of Art and Life as Seen in the National Museum of Anthropology*. New York: Harry N. Abrams, Inc., n.d.

Bernal, Ignacio. *Mexico Before Cortez: Art, History, and Legend*. New York: Doubleday & Co., 1963.

Blom, Frans and La Farge, Oliver. *Tribes and Temples: A Record of the Expedition to Middle America Conducted by the Tulane University of Louisiana in 1925*, 2 vols. New Orleans: Tulane University, 1926, 1927.

Carlson, Loraine. *Mexico: An Extraordinary Guide*. New York: Rand McNally & Co., 1971.

Charleston, Robert J., ed. *World Ceramics*. Secaucus, N.J.: Chartwell Books, 1976.

Charpenel, Mauricio. *Las Miniaturas en el arte popular mexicano.* Latin American Folklore Series no. 1. Austin: University of Texas, Center for Intercultural Studies in Folklore and Oral History, 1970.

Coe, Michael D. *The Jaguar's Children: Pre-Classic Central Mexico.* New York: The Museum of Primitive Art, 1965.

Cordry, Donald Bush and Cordry, Dorothy M. *Mexican Indian Costumes.* Austin: University of Texas Press, 1968.

Covarrubias, Miguel. *Indian Art of Mexico and Central America.* New York: Alfred A. Knopf, 1957.

————. *Mexico South: The Isthmus of Tehuantepec.* New York: Alfred A. Knopf, 1947.

Cumberland, Charles C. *Mexico: The Struggle for Modernity.* New York: Oxford University Press, 1968.

Davies, Nigel. *The Aztecs.* New York: G. P. Putnam's Sons, 1974.

Davis, Mary L. and Pack, Greta. *Mexican Jewelry.* Austin: University of Texas Press, 1963.

Díaz, May N. *Tonalá.* Berkeley: University of California Press, 1966.

Dockstader, Frederick J. *Indian Art in Middle America.* Greenwich, Conn.: New York Graphic Society, 1964.

Dörner, Gerd. *Folk Art of Mexico.* Munich: Wilhelm Andermann Verlag, 1962.

Driver, Harold E. *Indians of North America,* 2d ed., rev. Chicago: University of Chicago Press, 1970.

Espejel, Carlos. *Las artesanías tradicionales en México.* Mexico City: Secretaría de Educación Pública, 1972.

————. *Mexican Folk Ceramics.* Barcelona: Editorial Blume, 1975.

Fondo Editorial de la Plástica Mexicana. *The Ephemeral and the Eternal of Mexican Folk Art,* 2 vols. Mexico City: Banco Nacional de Comercio Exterior, 1971.

Foster, George M. "Archaeological Implications of the Modern Pottery of Acatlán, Puebla, Mexico." *American Antiquity* 26 (1960):205–14.

————. "Contemporary Pottery and Basketry." In *The Handbook of Middle American Indians,* vol. 6. Edited by Manning Nash. Austin: The University of Texas Press, 1967.

————. "Contemporary Pottery Techniques in Southern and Central Mexico." Middle American Research Institute of Tulane University, pub. no. 22. New Orleans: Middle American Research Institute, 1955.

————. *Empire's Children: The People of Tzintzuntzan.* Westport, Conn.: Greenwood Press, 1973.

————. "The Sociology of Pottery: Questions and Hypotheses Arising from Contemporary Mexican Work." In *Ceramics and Man.* Edited by Frederick R. Matson. Wenner-Gren Foundation, Viking Fund, pub. no. 41. New York: Wenner-Gren Foundation, 1965.

————. "Some Implications of Mexican Mold-Made Pottery." *Southwest Journal of Anthropology* 4 (1948):356–70.

————. *Tzintzuntzan: Mexican Peasants in a Changing World.* Boston: Little, Brown & Co., 1967.

Gamboa, Fernando. *Masterworks of Mexican Art, from Pre-Columbian Times to the Present.* Los Angeles: Los Angeles County Museum of Art, 1963.

Girard, Alexander. *The Magic of a People.* New York: Viking Press, 1968.

Griffith, James S. *Legacy of Conquest: The Arts of Northwest Mexico.* Colorado Springs: Colorado Springs Fine Arts Center and Taylor Museum, 1967.

Grove, Richard. *Mexican Popular Arts Today.* Colorado Springs: Colorado Springs Fine Arts Center and Taylor Museum, 1954.

Gutiérrez, Tonatiuh and Gutiérrez, Elektra. "El Arte Popular de México." Mexico City: *Artes de México, Número extraordinario,* 1970–71.

Hamill, Hugh M., Jr. *The Hidalgo Revolt: Prelude to Mexican Independence.* Gainesville: University of Florida Press, 1966.

Hendry, Jean Clare. "Atzompa: A Pottery Producing Village of Southern Mexico." Ph.D. dissertation, Cornell University, 1957.

Hoffmann, Carlos C. "La indústria de Talavera de Puebla," *Cosmos,* no. 26. Mexico City: 1918.

Houston, Margaret and Wainer, Judith Carson. "Pottery-Making Tools from the Valley and Coast of Oaxaca." *Boletín de Estudios Oaxaqueños,* bulletin no. 36. Oaxaca, Mexico: Museo Frissell de Arte Zapoteca, 1971.

Huitrón, Antonio H. *Metepec: Miseria y grandeza del barro.* Mexico City: Instituto de Investigaciones Sociales de la Universidad Nacional, 1962.

Instituto Nacional Indigenista. *Bibliografía de las artes populares plásticas de México,* 2 vols. Mexico City: Memorias del Instituto Nacional Indigenista, 1950.

Kelemen, Pal. *Art of the Americas, Ancient and Hispanic.* New York: Thomas Y. Crowell Co., 1969.

Krevolin, Lewis. "Mexican Indian Pottery: A Living Tradition." *Craft Horizons* 36:18ff.

Kubler, George. *Mexican Architecture of the Sixteenth Century,* 2 vols. New Haven: Yale University Press, 1948.

Lead Industries Assn., Inc. "Facts About Lead Glazes for Art Potters and Hobbyists." New York: Lead Industries Assn., Inc., 1971.

Litto, Gertrude. *South American Folk Pottery.* New York: Watson-Guptill Publications, 1976.

Marín, Isabel de Paalen. "Alfarería: Tonalá." In *Jalisco en el arte.* Guadalajara, Mexico: Editorial J. R. Alvarez, n.d.

———. *Historia general del arte mexicano: Etno-artesanías y arte popular.* 2 vols. Mexico City: Editorial Hermes, 1976.

Martínez Caviro, Balbina. *Catálogo de cerámica española.* Madrid: Instituto Valencia de Don Juan, Ediciones Ibero-Americanas, 1968.

———. *Cerámica de Talavera.* Madrid: Instituto Diego Velázquez del Consejo Superior de Investigaciones Científicas, 1969.

Mason, J. Alden. "The American Collections of the University Museum and the Ancient Civilizations of Middle America." University of Pennsylvania Museum Bulletin, vol. 10, nos. 1–2. Philadelphia: University of Pennsylvania Museum, 1943.

Mercer, Henry C. "The Kabal, or Potter's Wheel, of Yucatán." Bulletin of the Free Museum of Science and Art, vol. 1, no. 2. Philadelphia: University of Pennsylvania, 1897.

Muller, Florencia and Hopkins, Barbara. *A Guide to Mexican Ceramics.* Mexico City: Minutiae Mexicana, 1974.

Murillo, Gerardo. *Las Artes populares en México,* 2d ed. 2 vols. Mexico City: Secretaría de Indústria y Comercio, 1922.

Museum of Modern Art, New York, and Instituto de Antropología e Historia, Mexico City. *Twenty Centuries of Mexican Art.* New York: Museum of Modern Art, 1940.

Nelson, Glenn C. *Ceramics,* 2d ed. New York: Holt, Rinehart & Winston, 1960.

Norman (Schmidt), James. *In Mexico: Mexican Popular Arts and Crafts.* New York: William Morrow & Co., 1959.

———. *Terry's Guide to Mexico,* rev. ed. New York: Doubleday & Co., 1972.

Norman (Schmidt) James, and Schmidt, Margaret Fox. *A Shopper's Guide to Mexico.* Garden City: Doubleday & Co., 1966.

Parsons, Helen Clews. *Mitla, Town of the Souls.* Chicago: University of Chicago Press, 1936.

Payne, William O. "A Potter's Analysis of the Pottery from Ambityeco Tomb 2." In *Boletín de Estudios Oaxaqueños*, bulletin no. 29. Oaxaca, Mexico: Museo Frissell de Arte Zapoteca, 1970.

Poupeney, Mollie. "Rosa Real de Nieto: Mexican Potter." *Ceramics Monthly* 22 (1974):24–29.

Powell, Philip W. *Soldiers, Indians and Silver*. Berkeley: University of California Press, 1952.

Pozas, Ricardo. "La alfarería de Patamban." *Anales* [del Instituto Nacional de Antropología e Historia] 3 (1949):115–46.

Raluy Poudevida, Antonio, comp. *Diccionario Porrúa de la Lengua Española*, 3d ed. Revised by Francisco Monterde. Mexico City: Editorial Porrúa, 1970.

Ramírez Vázquez, Pedro. *Mexico: The National Museum of Anthropology*. New York: Harry N. Abrams, Inc., 1968.

Sayer, Chlöe. *Crafts of Mexico*. New York: Doubleday & Co., 1977.

Shepard, Anna O. *Ceramics for the Archaeologist*. Carnegie Institution of Washington, pub. no. 609. Washington, D.C.: Carnegie Institution, 1971.

———. *Plumbate—A Mesoamerican Trade Ware*. Carnegie Institution of Washington, pub. no. 573. Washington, D.C.: Carnegie Institution, 1948.

———. "Notes from a Ceramic Laboratory: Beginnings of Ceramic Industrialization." Washington, D.C.: Carnegie Institution of Washington, 1963.

———. "Rio Grande Glaze Paint Ware." In *Contributions to American Anthropology and History*, vol. 7. Carnegie Institution of Washington, pub. no. 528. Washington, D.C.: Carnegie Institution, 1942.

———. "Rio Grande Glaze-Paint Pottery: A Test of Petrographic Analysis." In *Ceramics and Man*. Edited by Frederick R. Matson. Wenner-Gren Foundation, Viking Fund, pub. no. 41. New York: Wenner-Gren Foundation, 1965.

Simpson, Lesley Byrd. *Many Mexicos*, 3d ed., rev. Berkeley: University of California Press, 1957.

Taylor, Paul. "Making Cántaros at San José Tateposco." *American Anthropologist* 35 (1933): 745–51.

Toneyama, Kojin. *The Popular Arts of Mexico*. Tokyo: Weatherhill, 1974.

Toor, Frances. *Mexican Popular Arts*. Mexico City: Frances Toor Studios, 1939.

Toscano, Salvador. *Arte precolombiano de México y de la América Central*. Mexico City: Instituto de Investigaciones Estéticas, Universidad Nacional Autónoma de México, 1944.

Van de Velde, Paul and Van de Velde, Henriette Romeike. "The Black Pottery of Coyotepec, Oaxaca, Mexico." Southwest Museum Papers, no. 13. Highland Park, Los Angeles: Southwest Museum, 1939.

Villegas, Victor Manuel. *Arte popular de Guanajuato*. Mexico City: Banco Nacional de Fomento Cooperativo, Talleres Gráficos de Librería Madero, 1964.

Von Winning, Hasso, *Pre-Columbian Art of Mexico and Central America*. New York: Harry N. Abrams, Inc., 1970.

Index

Acapulco (Guerrero), 84
Acatlán (Puebla), 12, 20, 44, 65, 71, 78–82,
 113–15
acid foods (effect on glazes), 49–51
African influence on pottery, xv
Aguilar, Josefina, 102–3
Alvarez Sánchez, María Guadalupe, 111–12
amate painting, 84–86
Amatenango del Valle (Chiapas), xv, 32
Ameyaltepec (Guerrero), 84, 86
apaxtle, 60
Aquixtla (Puebla), xv, 14
artisans, Spanish, 76, 90, 91
Atzompa (Oaxaca), 21, 83, 103, 105
Aztec Indians, 82

Balsas-Mexcala (Guerrero) area, 78, 84
bark-paper painting. *See amate* painting
barril, 60, 64
barrio de la luz (Puebla), 76
barrio of San Luisito (Guanajuato), 21
barro blanco, 49
batting tool, 39
bisque fire, 15, 18, 24
bisqueware, 15, 21, 36, 78
blackware, 19–20, 69, 83, 93
Blanca Espuma (Veracruz), 32
Blanco, Teodora, 103–4
botellón, 99, 100
bottle. *See botellón*
brazier, 78, 82

bruñido, 98, 99, 100, 111
burial jars, 60, 64
burnished wares, 83, 93, 99
burnishing, 43–44, 80, 98, 100
burnishing tools, 44, 99, 100

cajete, 60
candelabra, 78, 81, 88
cántaro, 65, 69, 81, 84, 95
cántaro salinero, 65, 71
Capula (Michoacán), 39
Casa de las Artesanías de Jalisco (Guadalajara),
 109
cazo, 55
cazuela, 50, 55, 69
Chiapa de Corso (Chiapas), xv
Chiapas, State of, 1, 32
Chilpancingo (Guerrero), 84
chimenea, 99
chivo de chía, 83
clay and clay bodies, 25–51, 69, 80, 118; mixture
 of bodies, 30; "natural bodies," 30
clay preparation, 26–30
clay sources, 26, 44, 88
clay "tempers," 30
colander, 52, 60
comal, 55, 60, 69
conquistadors, 76
copper, in lead glazes, 50
corriente, xiv, 52–71, 78, 81, 83, 84, 91, 95
Cortés, Hernán, 55, 82
cottage industries, 97

Coyotepec (Oaxaca), 13, 19, 44, 69, 71, 80, 83, 93

devil figures, 95, 111
Díaz, Porfirio, 82
Dolores Hidalgo (Guanajuato), 15, 23, 90–92

El Rosario (Jalisco), 98, 100
Encarnación de Díaz (Jalisco), 16

family enterprises, 97, 102, 109–10, 112, 119
firemarks, 19, 71, 81
fireplace, portable. *See chimenea*
firing methods, xv, 1, 16–21, 24
firing temperatures, 1, 8, 17, 22
firing time, 1, 10–11, 21
flameware, 21, 52, 55
forced labor, 76, 90
Foster, George M., 39
fuel: cactus, 10, 79; cow manure, 1, 10; fuel oil, 10; gas, 23; kerosene, 10; rubber tires, 10; wood, 1, 9, 88

gesso, 78
glaze fire, 15, 18, 24
glazed ware, 17, 65, 76, 95, 98
glazes, 46–51, 80, 98; colored, 49–50; leadless, 22, 51
González, Gorky, 105–9
government influence on pottery making, xvi, 24, 51, 92, 95
greta, 48, 49
Guadalajara (Jalisco), 52, 97, 109
Guanajuato, city of, xv, 90, 91, 105–9
Guanajuato, State of, 36, 90–92, 105–9
Guerrero, Fortino, 23
Guerrero, State of, 1, 32, 72, 84–87
guild system, 76, 90

Hidalgo y Costilla, Miguel, 36, 91
Huánzito (Michoacán), 44
Huapan (Guerrero), 84, 86
Huaquechula (Puebla), 78

incense burners. *See* braziers
Indian slaves, 76
indigenous influences on pottery, xv, 1, 26, 30, 32, 36, 39, 47, 55, 60, 80, 82, 83, 84, 91, 92, 95, 105
innovators, 101, 102, 115
Isthmus of Tehuantepec, 36
Izúcar de Matamoros (Puebla), 77–78

Jalisco, State of, xv, 26, 97–100, 109–10, 117–18, 121–24
Jimón, Pablo, 109–10
Jimón family, 109–10
Juárez, Benito, 82
Juchitán (Oaxaca), xv, 36

kabal, 36, 60, 80, 83
kiln design: adobe, 8; bottle, 15; corbeled dome, 22, 119; electric, 23; high-temperature, 24; multichambered, 15; open-top (also known as the Arabic, Mediterranean, and Moorish kiln), 8–13, 15, 16, 21, 24; partially domed, 14; rubble, 11; subterranean, 13, 83; tunnel, 15
kiln size, 11

La Trinidad Tenexyecac (Tlaxcala), xv, 69
Lake Pátzcuaro, 92–93
lead poisoning, 49–51
"lead scare," 49–51
litharge, 48
loza fina, 65, 72

majolica, 48, 72, 76, 77, 91, 108
Martínez Benito, Teodoro, 111–12
Martínez Mendoza, Herón, 12, 113–15, 119
Matlanzinca Indians, 88
Medrano, Candelario, 117–18
Mera, Gregoria, 109–10
metate, 30, 55
Metepec (Mexico), 13, 20, 69, 78, 88–90, 119–21
Mexico City, xv, 24, 39, 52, 75, 84, 88, 91
Mexico, State of, 20, 24, 69, 88–90, 119–21
Michoacán, State of, 1, 20, 92–95, 111–13
Mitla, 83
Mixe Indians, 60
Mixtec Indians, 79, 82
modeling, hand, xv, 32, 80, 95, 113
molcajete, 60
molde. See kabal
molds, 36–39, 80, 98, 123; bisque, 36, 39; concave, 39; convex, 39; mushroom, 39; plaster, 39; press, 39, 91, 98; vertical seam, 39
Monte Albán, 82, 83
Monterrey (Nuevo León), xv, 39, 52, 77
Moorish influence on pottery, 76, 81, 99
mythology, influence on pottery, 89–90

nativity scenes, 105

Oaxaca, city of, xv, 15, 64, 83, 105, 114

Oaxaca, State of, xv, 19, 36, 60, 78, 82–83, 102–5
Oaxaca, Valley of, 82–83
Ocotlán (Oaxaca), 102–3
Ocumicho (Michoacán), 93, 95, 111–12
olla, 52, 55, 60
open firing, 1, 21, 84

Pahuamba, Benito, 44
paint, 12, 45, 78, 86, 90, 113, 118, 119
painters, 98, 111
Pan American Highway, xv, 77, 83
parador. See kabal
Patamban (Michoacán), 93, 95
patojo, 60
Persian influence on pottery, 99
petate, 98
petatillo, 98, 99, 100
pichancha, 52, 60, 84
piña. See pineapple forms
pineapple forms, 93, 95
planters, garden, 82, 83, 84
plasticity of clay, 25, 27, 30
plato. See kabal
Plumbate wares, 46
potter's wheel, 36, 91, 98, 109, 123
Puebla, city of, 14, 72, 75–77
Puebla, State of, xv, 14, 65, 71, 75–82, 113–15
pulverizing tools, 30

Quiroga, Vasco de, 92

raku, 21
reduction, 20–21
Regional Ceramic Museum, Tlaquepaque, 109
religious influences on pottery, 78, 82, 83, 88, 89, 91, 105
Río Balsas (Guerrero) area, 84–87
Rio Grande Glaze Paint Wares, 46
rolling pin technique, 39

San Blas (Tehuantepec), xv
San Isidro Labrador festival, 89, 119
San José de Gracia (Michoacán), 93, 95
Santa Cruz de las Huertas (Jalisco), 117
Santa Fe de la Laguna (Michoacán), 92
Shepard, Anna O., 1
silver mining, 90
slip casting (rarity of), 39
slip painting, 86, 87, 98
slips, 44–46
slow wheel, xv, 36

smudging, 20, 80
Soteno Fernández, Alfonso, 13, 119–21
Spanish influences on pottery, 26–27, 36, 39, 47, 48, 75–77, 83, 88, 90, 91, 92, 98
stacking (of kilns), 16–21, 22, 49
stoneware, high-temperature, 24, 123
storage (of clay), 26, 27
stucco painted wares, 45
surrealism, 105, 118

Talavera pottery, 76, 77, 91
Talavera de la Reina (Spain), 76, 77
Tarascan Indians, 44, 92, 93
Tarascan Sierra, 93–95
Tatepozco (Jalisco), 98, 100
Taxco (Guerrero), xv
Tehuantepec (Oaxaca), xv
Tehuitzingo (Puebla), 11, 78
Temascalcingo (Mexico), 24
thermal shock resistance, 21, 22
throwing, 27; speed of, 36, 91
tiles, xv, 55, 76, 77, 91
tina, 60
tinaja, 60, 64, 69, 84, 95
tinajera, xv
Tlaquepaque (Jalisco), xv, 97, 109
Tlaxcala, State of, 69
Toledo (Spain), 76
Toluca (Mexico), 88
Toluca, Valley of, 88
Tonalá (Jalisco), 23, 26, 44, 97–100, 121–24
tree-of-life, 12, 22, 72, 81, 88–89, 115
Tulimán (Guerrero), 84
tumpline, 65
Tuxtla Gutiérrez (Chiapas), xv
Tzintzuntzan (Michoacán), 20, 44, 92–93

Valle de Bravo (Mexico), 24
varnish, 45, 78
Veracruz, city of, 75
Veracruz, State of, xv, 32

weather (as influence on pottery making), 27, 30
Wilmot, Jorge, 23, 117, 121–24

Xalitla (Guerrero), 84, 86

Zacatecas, city of, 90, 91
Zapotec Indians, 82, 105
Zipiajo (Michoacán), 1
zoomorphic forms, 82
Zumpango del Río (Guerrero), 1, 32, 84